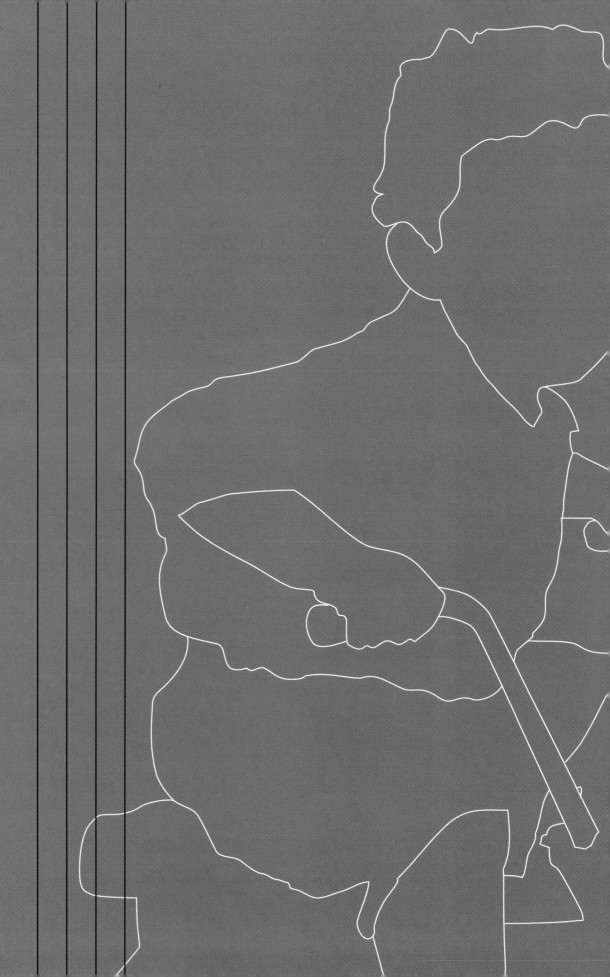

introduction

Most people's first steps into photography occur when they take pictures of family and friends. These 'happy snaps' sum up the appeal of this type of family portraiture – happy moments that have been captured and preserved.

What some snapshots may lack as examples of photographic skill they often make up for in other ways – the spontaneity of a special moment, or an unrepeatable event such as a toddler's first footsteps, a wedding or a graduation. However, when the range of subject matter found in family situations is combined with the right technique plus a more considered and creative approach, the result can be successful family portraiture that has strong visual, emotional and commercial appeal. Today's commercial family portraits owe much to the type and quality of the images seen on TV or video, at the cinema and in magazines. Many of these use colour, composition and even mood in original and creative ways. The techniques and compositional styles of these photographs are in a constant state of evolution, and photographers need to keep pace.

Photographers of family subjects will naturally be affected by good examples of such images and may wish to incorporate or develop such influences in their own work. There will be various reasons for this: because it enables them to develop their own style, a need to keep their images varied, or to make their work accessible to a more visually aware audience and potential clients. Many of the standard skills of professional portrait photographers can be applied to family portraiture. However, the photographer of family portraits needs to be aware that the images will be of special value to the clients, as they will form part of their personal memories.

This book shows just some of the tricks and techniques of the trade, enabling professional photographers to bring an innovative look and a new dimension to family portraits.

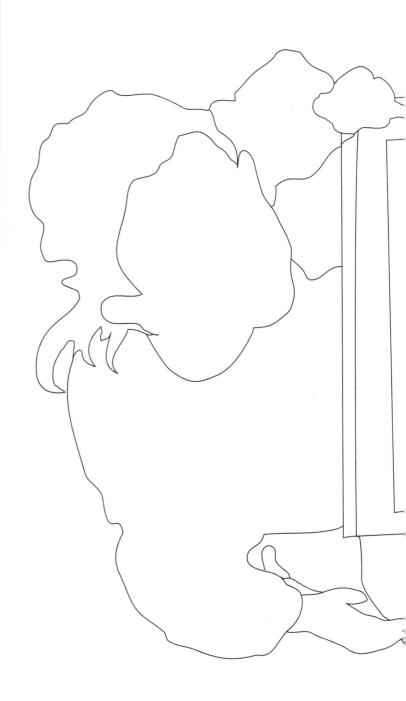

babies

a

1b.

1

"Babies grow up so fast that you'll want to capture their progress on film. The best pictures will always be those that are natural and unposed, so you'll need to work quickly and to shoot at a moment's notice

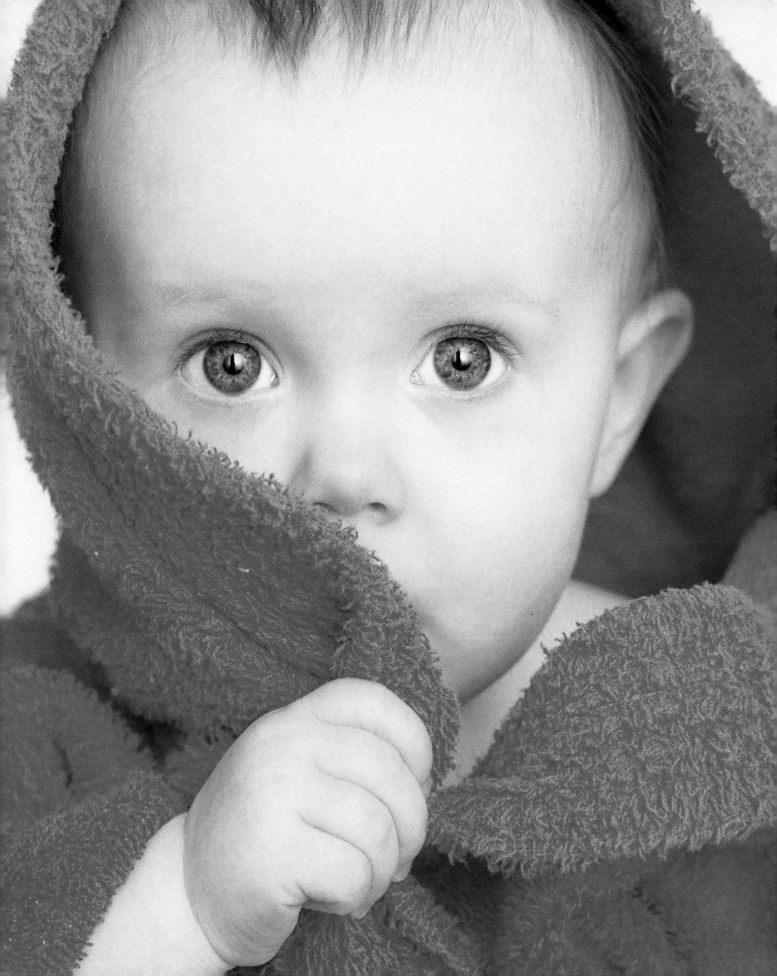

A camera can be an intimidating thing to a baby. A longer lens gives you the chance to step back and to allow the situation to develop more naturally.

technical details
100mm telephoto lens on a 35mm SLR, with an ISO 100 slide film.

Mood

You must be ready to capture the moment when it arrives, because you'll never stage manage a young child. Make sure that you've calculated the exposure, set the camera and framed the picture as you want it. A particularly effective approach is to frame tightly so that, as here, the child's face dominates the photograph. The power of the eyes is intense here: had there been wasted space around the face, much of the strength of the picture would have been lost.

For all this preparation, the portrait still required something extra to make it special. As the child pulled the towel across its face for an instant, the final touch was added and the picture was complete.

Technique

It's important not to intimidate your subject, so use a longer lens to allow a reasonable distance between you. A lens that is 85mm or longer will suit, but the best option is a zoom as it has the advantage of allowing you to adjust your framing quickly and without moving position. A power wind will also help to speed things up and will leave you with more opportunity to concentrate on what you're seeing through the lens.

Lighting

A softbox, positioned above and slightly in front of the baby, has produced soft, even lighting. Portraits of older faces, where wrinkles and texture might be vital elements of the character, would be ruined by the rather bland nature of the lighting that a softbox provides. In the case of a child, however, where it's usually desirable to emphasise the smooth and unblemished qualities of the skin, the gentle light provided by the softbox is ideal. The background has been lit by a separate diffused flash positioned behind the child. This too was softened to avoid the creation of distracting shadows in this area of the picture.

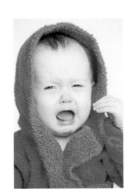

Technique

Photographer Gerry Coe wanted a tight and intimate portrait of this child with its father. A slightly long 135mm lens was fitted to his 6x6cm Mamiya C330 to give him the perspective he was after, and he asked the father to remove his shirt for a more natural look and to look down at his child so that his face didn't become a distraction.

"To attract the attention of the baby and to try to get a good expression, I'll make a complete idiot of myself," says Coe. "I might whistle, make funny noises, blow raspberries, absolutely anything to get a reaction. That might not necessarily be a smile: I love serious pictures as well, where the child is just looking directly into the camera. I want to get some character on film, and there is a lot more to that than just a smile."

Composition

The crop of this picture was tight so that the father became the backdrop for the image. "I used the parent in this case almost as a prop," says Coe. "This was a baby that was still too young to sit up on its own, and so I needed to come up with a way of supporting it. I hate those twee images that you see where the child has been arranged on a velvet chair so that it's sitting up, and I thought this idea was much more natural and acceptable. The shape of the father's arm acts as a border to the picture, holding it together at the bottom of the frame, while the way it surrounds his child symbolises the idea of protection and adds further to the intimacy of the picture."

Lighting

This father and baby portrait was lit with two softboxes, set either side of the subjects. At equal distance they would have provided very even and soft lighting, but Coe wanted to introduce a certain amount of modelling and so the softbox to his right was positioned further back and used at half power. "The kind of softbox that you use will have an influence on the kind of picture you produce," says Coe. "I do know people who insist on using a round softbox because they prefer the catchlight that this provides in the subject's eye, but I'm happy with the rectangular softboxes that I use. I think the shape of the catchlight that this gives me is still perfectly acceptable for portraits."

"It's not so much about developing trust, but more about developing the feeling that what we're doing is a collaboration. I'm interested in what we can do together, not what we can do separately."

Annie Leibovitz on her approach to photographing Hollywood stars

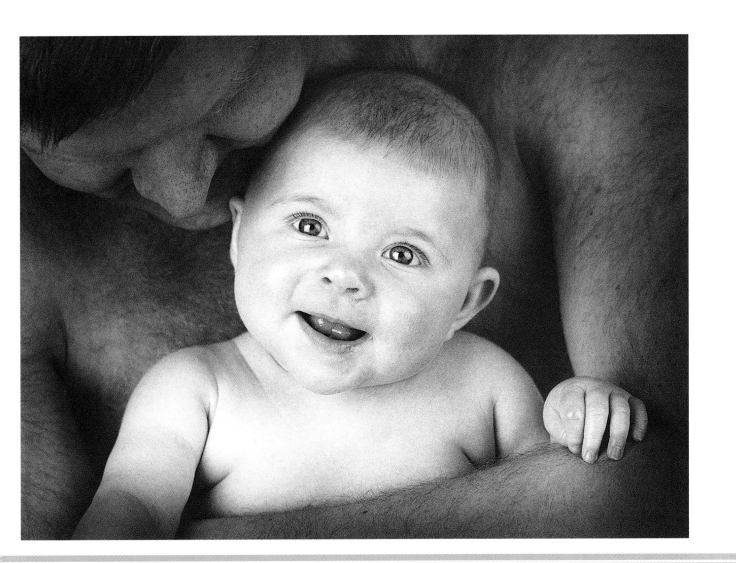

15 BABIES WITH PARENTS

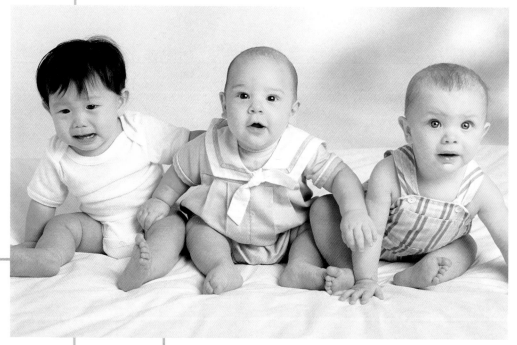

When shooting multiple subjects, make sure the parents are on hand to calm their children and to help to amuse them.

When you set up a picture of this kind, it's helpful to have at least one parent on hand for each child being photographed. Children of this age are reassured by familiar faces, and are more likely to give you a few moments of co-operation if someone is around to calm them and to attract their attention when necessary. If one of your sitters decides it's time for a cry, then don't try to keep everything set up. Children have very short attention spans, and by the time one child has been calmed it's likely that the others will have decided that they've been sitting for too long in one position and will want to move. Keep some favourite toys handy and make sure that the session is as interesting as possible for your subjects.

Lighting
A softbox light source was used to provide the illumination for this picture, because of the wide even spread of light that it was capable of providing. Used on its own in this situation, however, its effect still would have been too directional, and so reflectors were set up around the children to bounce light back into the scene and to remove something like 90 per cent of the shadows that would otherwise have been thrown. Naturally the photographer took the opportunity to check, via Polaroids, the way the lighting was working well in advance of the shoot getting under way, so that when his subjects got in front of the camera everything was set up and ready to go.

Composition

The picture in its final form is a classic triangle shape, with the baby arranged to be the focal point of interest. The two heads at the top of the frame are tilted and at different levels, which has helped to give the picture a much livelier feel than a more symmetrical composition would have done. Levels are vital in a picture of this kind, and you should always try to create a series of steps within a composition so it holds interest and gives the eye a reason to travel around a picture. "Judicious cropping can also add greatly to the impact that a photograph achieves: You don't need to see details such as the top of the boy's head," says Gerry Coe.

Technique

This baby had been crying through much of the picture session and only when he finally went to sleep was it possible to set up an arrangement which featured all three of the children together. Photographer Gerry Coe brought them together in a tight arrangement, and used the slightly long 135mm lens on his Mamiya C330 6x6cm camera to allow him to keep a suitable distance from his subjects so that they weren't intimidated, and were more likely to look natural. When he came to print the negative, however, Coe felt that the dynamics of the picture could have been stronger, and so he tilted the image on the baseboard to come up with this arrangement. To get some idea of how the picture looked before this treatment, the boy's arm on the left of the picture was originally level in the frame: the twist has added vitality without the eye being able to perceive that anything has been changed.

Lighting

Two softboxes, one either side of the photographer and both set at 45 degrees to the children, were used to provide the illumination here. The main one was to the left of the photographer and was used full power, while the second, to the right, was adjusted to be around one stop weaker so that some modelling was created.

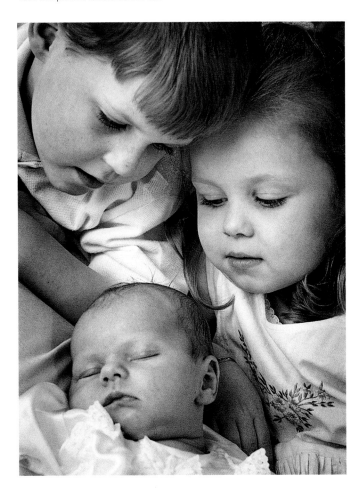

Technique

A child by nature is lively, and you want to capture that in your pictures, but you'll need to work virtually in a candid style if you're going to produce pictures that look spontaneous and natural. Young children don't understand the idea of posing, and so all you can hope to do is to set up a situation that appeals to them, and then capture it on film. By asking a parent to play a game with this little girl, the photographer has set up a situation that is fun and far from intimidating. The animation that has resulted, and the happy sparkle in the eyes, could never have been set up in any other way. A session such as this is enjoyable for all concerned, and you'll get much more time with the child before the inevitable boredom threshold is reached.

Using a zoom lens has also allowed a variety of crops to be achieved in-camera here, without the photographer having to change position. Look for a lens that can zoom from a standard setting through to a medium telephoto, so that you can feature everything from a half-length portrait through to head and shoulders and a tight facial crop.

Lighting

Two softboxes provided the illumination for this portrait, both mounted above the child and positioned either side of the photographer. The light coming from the right has been used as the key light, while the one from the left has been positioned further back and is acting as a much more gentle fill light. The combination of the two sources has created some shadow under the girl's neck and added useful modelling. The girl herself stands out almost in relief against a background that has been left deliberately dark: just a little light has reached this point, which has been enough to allow a degree of tone to be recorded, though not enough to create a distraction.

Composition

As adults we're all too used to looking down on children, but the photographer will find that a much more agreeable viewpoint is the one that takes the camera down to the level of the child itself, or even moves to just a degree below this. The result is a much more natural composition, one where less distortion has been created and where the child has more chance of dominating the picture.

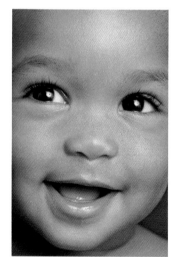

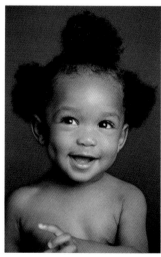

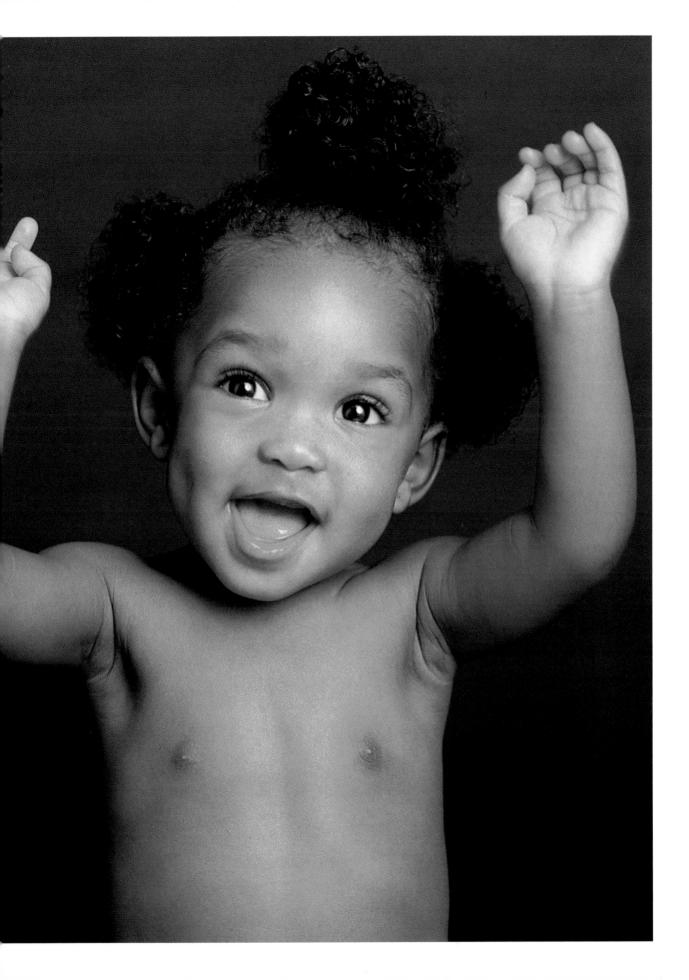

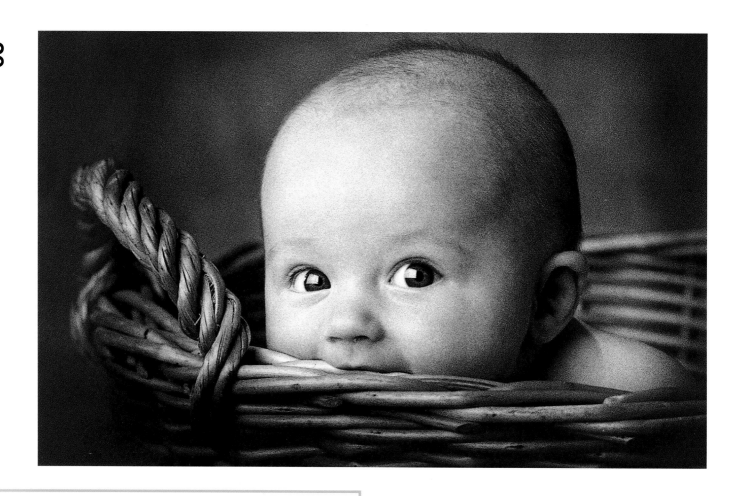

Technique

Props can add greatly to a picture of a baby. They can give the child something to play with and to react to, but they have to be chosen carefully if the final result isn't to look too contrived. "I very rarely use any props at all," says photographer Gerry Coe, "because I think that after a while they tend to look a little tacky. However, there are times when a very simple one can benefit a picture enormously."

"I use a wicker basket, for example, for times when a baby is so young that it can't sit up unaided. Rather than put something behind to act as a support, which can look pretty awful, I sometimes use the basket and allow the child to explore and then wait to see what is going to happen."

"In this case the baby moved forward and then pulled herself up and started to chew on the edge of the basket. She was putting a lot of pressure on her mouth, and her mother was set to rush in to pick her up, but I managed to fire off three pictures and that was it." Eye contact was vital, and Coe got exactly what he wanted, shooting from close in and using an 85mm (standard) lens on his C330 6x6cm camera.

Lighting

Two softboxes were used for this picture. One was used as the main light source, and was positioned high and to the left of the photographer. The other was directed into the corner of the studio behind the photographer and to his right, so that its light reflected back in a softened and weakened form on to the subject to provide a very subtle fill. Bouncing light in this way takes away much of the contrast, but if you're using colour film you must ensure that you're working with a surface that is pure white. If you bounce from a coloured surface, the light will pick up some of its hue, and will give the picture an unwanted colour cast.

Technique

Sometimes a prop can be something that is remarkably simple, but will capture a child's imagination and encourage them to perform for the camera. Gerry Coe often wraps his subjects in a towel, and then sits back to see how they play with it, ensuring of course that he is ready to capture the results on film. "This particular child unravelled the towel I'd put around her," he says, "and then, on just one occasion, held it up in front of her eyes. That was all I needed and, because I was ready to shoot, I got the picture I wanted."

Lighting

This is a high-key picture and, to get the effect he wanted, Gerry Coe lit the child with two equally balanced softboxes, set at 45 degrees either side of the subject. Two further lights were directed on to the background to ensure that no tone recorded there, and they were positioned so that no illumination from these sources added to the light on the subject. "I set my lighting so that it covers quite a wide area," says Coe. "This is really important when you're photographing babies and children, because they move around quite a lot and it means I can follow them. If I had my lights set to give coverage just for one tiny area, then I would be changing the set-up all the time."

Composition

A low camera angle ensured that Coe was level with his subject and able to make a strong feature of the eye contact that was achieved. "I spread the legs of the tripod I'm using so that it is almost as low as it can go," he says, "and this means that the camera is something like two feet off the ground. Then I usually work off my knees, so that I'm close to the level of my subject. The Mamiya C330 I use features a waist-level finder so I can look down on the viewfinder. Generally, however, I set the picture up, make sure that the focus is correct, and then work from the side of the camera without looking through the viewfinder in any case. If I was looking through the camera at my subject, all they would see is the top of my head, and that wouldn't make them smile."

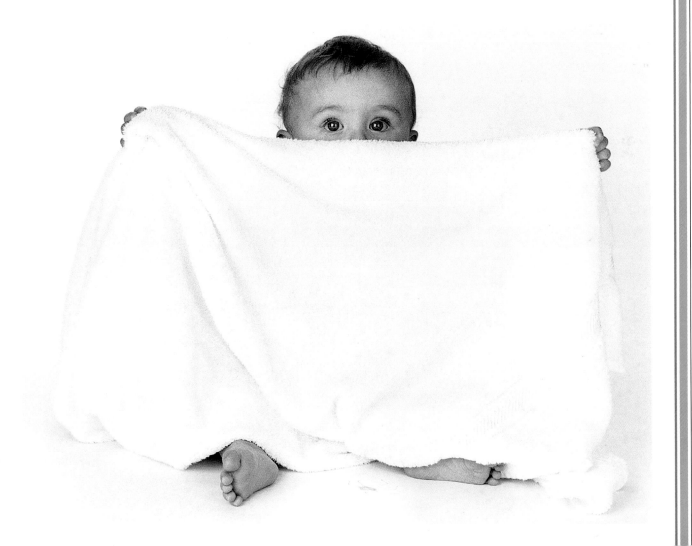

Baby portraiture doesn't have to be conventional. Show just a tiny part of the child and introduce a natural element to give scale, and you've made a visual point about how small and vulnerable a tiny baby is.

Composition

Simple is best with a picture of this kind. A baby has the instinct to squeeze a finger that is put within its reach, and this act can be the basis for a sensitive and emotional picture. Don't clutter up the background with too much detail and don't include too much of the surroundings. Crop in tight and focus on the point of interest. Nothing else matters, and this portrait says just as much about the bond between a parent and child as any more conventional approach would.

Technique

Aim for a shallow depth of field, so that everything in the picture apart from the central point of interest is thrown out of focus. Beware, however, that if you're using colour film, you'll need to look out for anything in the background that might still distract through its brightness. Use a telephoto lens, something like a 135mm would be ideal and set the widest aperture you can. An SLR will let you see exactly what you're going to achieve on film, and you can judge the picture accordingly. This kind of moment doesn't call for lightning-fast reactions: take your time, check the background and surroundings carefully, and make sure you're happy with the arrangements in your viewfinder.

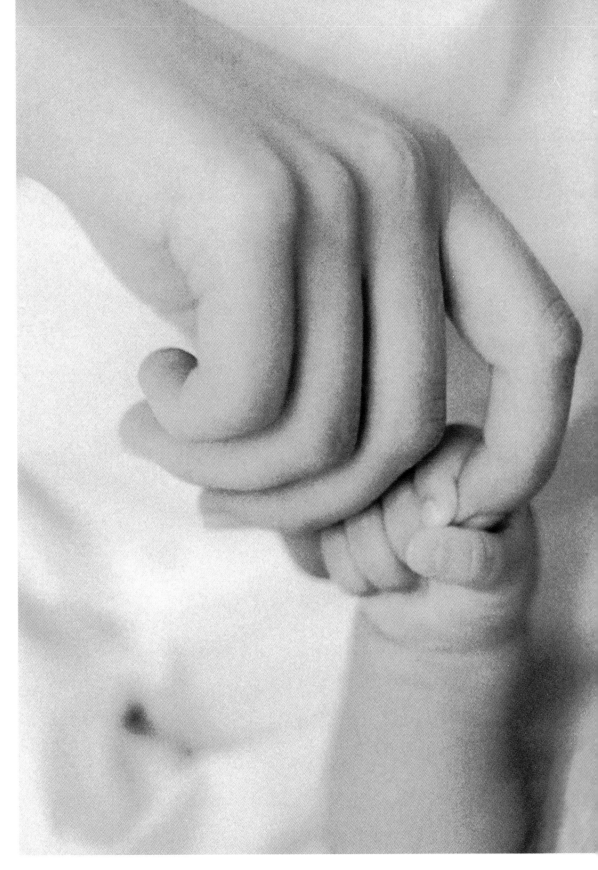

Lighting

Once again simplicity is the key to things here. Use just the one light and, if necessary, bounce some of it back into the picture to soften the shadows a little by using a reflector. For this you could use a purpose-made model or even adapt what is around as necessary. A sheet of plain white card, a newspaper or a sheet of polystyrene can all perform the role perfectly well.

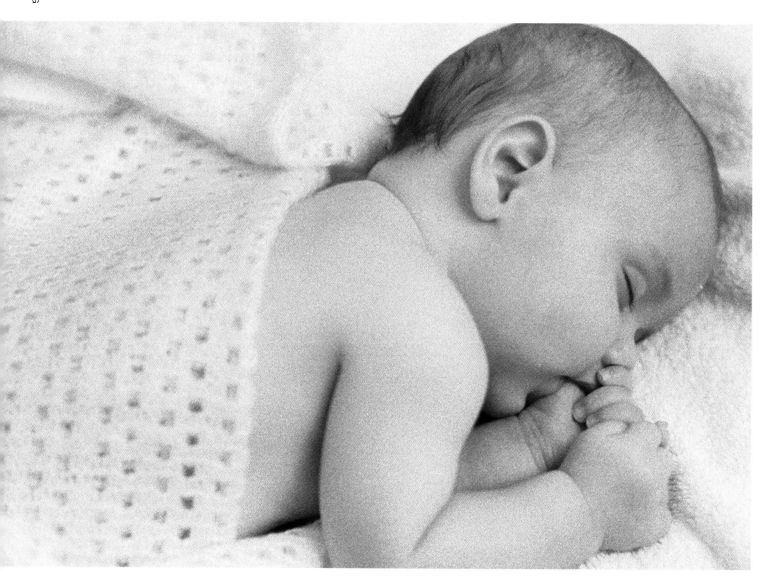

Composition

There are two points that have been mentioned several times already, and these are both relevant again here. First, keep it simple: put the child down to sleep on sheets that are plain and, if you're using colour film, are either white or feature subdued hues. Secondly, crop in tight. A photograph that features a sleeping baby as one tiny element of a much wider picture will lose all its impact. If you get in close, and crop to include just the head and shoulders of the child, then your picture will be much more effective.

Toning

A wide range of toners is available that will allow you to tone your black-and-white print almost any hue you desire. A favourite among photographers is Thiocarbamide, which allows a full range of tones from dark browns right the way through to a subtle brown to be introduced, while others, such as Selenium, will make the picture colder and bluer. You can also blue tone, gold tone or even, if you choose to opt for more advanced techniques, mix tones so that the final print contains elements of more than one colour.

Lighting

Try to use soft and even lighting when photographing babies indoors. Never use direct flash, because this will be far too harsh and will only disturb the child, although you could look at the possibility of bouncing the flash from a suitable wall or ceiling. This will reduce the intensity of the flash by around two stops, and so you will need to compensate for this in the exposure, but it will create a lovely soft and even light that might be much more suitable for a subject of this kind.

Colour

The sepia tone used here gives a distinctive character to any image, conveying a mood that is nostalgic and romantic. It's in direct contrast to the more usual colour pictures that are seen of children, and has all the more impact because of that. It's a very simple procedure to carry out, and requires very little in the way of darkroom equipment. First a normal black-and-white print is produced, and then this is placed in a bleach bath. The tones of the picture are gradually bleached away, and the photographer has the choice of when to remove the print and to stop the bleaching process. Bleaching completely back to a faint image creates a soft brown finish in the final sepia print, while partial bleaching makes the finish a much harder and deeper brown. Once bleaching is complete, the print needs to be washed thoroughly and then placed in a second, toning, bath. This will almost immediately bring the print back up to strength, but with the characteristic sepia finish. The print then needs to be washed thoroughly and dried to finish.

Babies don't have to be awake to make a wonderful subject. A gentle portrait of a sleeping child can work beautifully, but you need to consider carefully the lighting and background that you use.

As they grow older children become a more challenging subject. You'll need to develop a whole range of new action photography skills to capture their movement and lively expressions

Lighting

Light came from a softbox at the girl's right, from a distance of four feet. Then a 3x6ft circular reflector was placed at her left.

Composition

The wicker chair serves as an excellent visual prop and also provides a support for the girl's arm, while the hands form a frame for her face.

Technique

A medium telephoto lens was used on a medium-format camera. One of the effects of a telephoto lens is to flatten perspective, and here it makes it seem that the girl's face, hands and the wicker chair are all on the same plane.

technical details
150mm telephoto lens on a medium-format camera. Film was Ilford FP4.

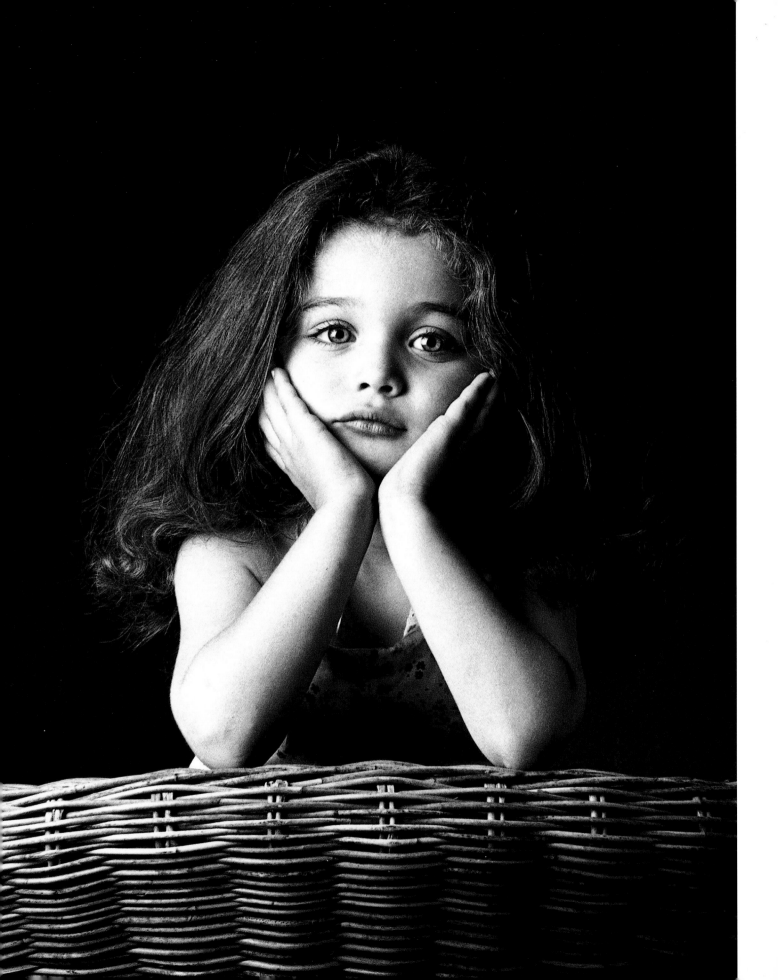

Technique

It is important that the photographer develops a good rapport with his subjects. The child will sense when the atmosphere in a studio is tense, and will react against that. Spend some time at the start of the session talking to your subject and putting them at ease. It is important that a parent is on hand to make them feel secure, and a favourite toy might also serve to help the child relax.

Composition

Don't imagine that a child needs to be smiling happily for every picture you take. That's just one expression and, as a child becomes older and more capable of putting on poses on demand, it might not appear that natural in any case. Learn to react to what the child will give you, and try to capture some of the character of your sitter, whether they be serious, moody or excited. Here, although there's no eye contact in this portrait, the picture still tells the viewer something about the personality of the child and, as part of a set, still has much to say.

Lighting

The softbox lighting requires minimal modification, and frees up the photographer. If preferred, a warm result can be achieved by using a filter or filter gels over the lens or the studio light. You could even choose to deliberately use daylight-balanced film in artificial light conditions to create a colour cast in the picture. Tungsten lighting will create a warm and quite attractive cast, but avoid shooting under fluorescent lights, which will give the scene you're shooting a very unflattering and cold blue/green cast.

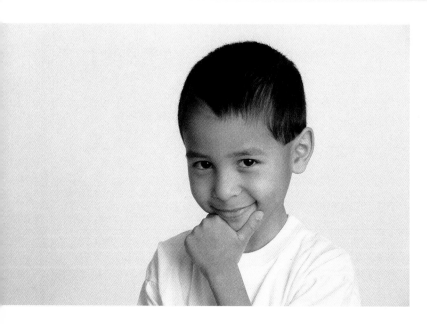

Up to about the age of ten most children pose easily for photographs, though they tend to have a short attention span. Children of five and above are rarely still unless captivated by a hobby or watching a film or some other diversion. The photographer will need to work quickly and yet have the necessary patience to make the most of such situations.

Children who are used to the camera learn how to strike a pose. This boy's expression shows that he's aware he is imitating an adult's pose.

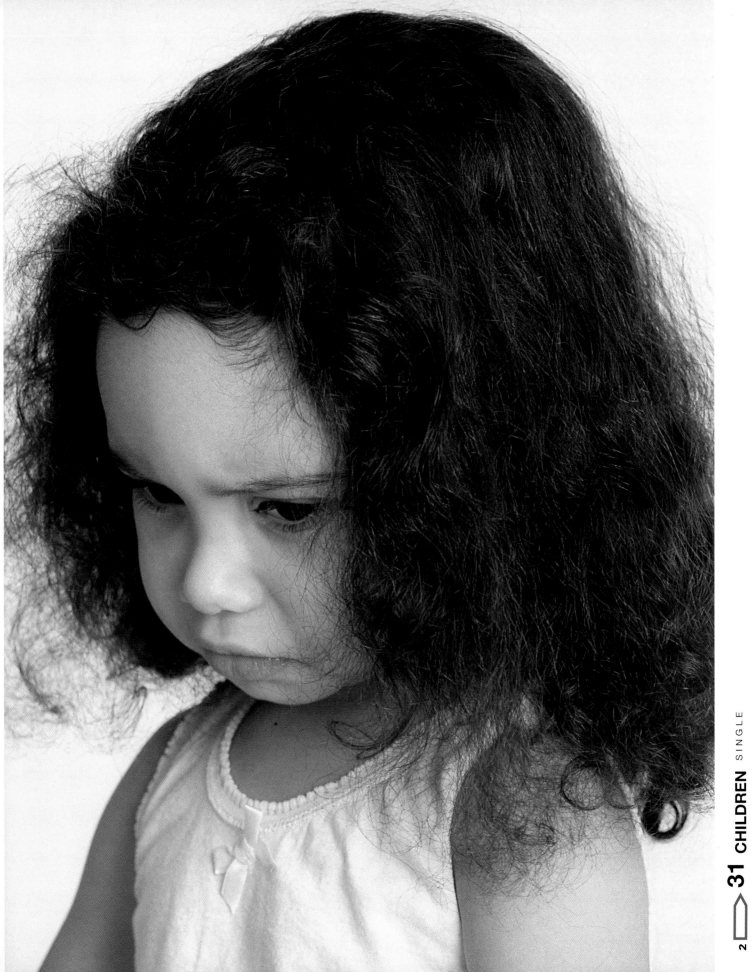

Composition
The girl's tilted head and cascading hair fill the frame well. This, plus her expression and the fact that she is looking at the camera and therefore the viewer, all combine to make a satisfying composition.

Colour
Her pale colouring and hair have been contrasted by the dark background and cerise top.

Technique
The cheapest element of photography is film, so be generous with it. Once you've set up a situation that looks promising, make sure that you exploit it to its full. A happy child will give you a full range of expressions and poses, and you should try to capture a variety of these if you can. A motor-drive, which will allow you to take several pictures a second, is overkill unless you're planning to capture an action sequence, but a power wind, which will advance film quickly without you having to take the camera away from the eye, can be invaluable. It will allow you to concentrate on your photography and will ensure that you're always ready to shoot.

To concentrate attention on the girl and her lively expressions, a plain background was used, and the photographer cropped in tight on just her head and shoulders. A lens that was slightly long was used to give a good perspective on her face, and to allow the depth of field to be relatively shallow. Using a wider lens could create unflattering distortion, and emphasise unduly features such as the nose, and it would also lead to an increased depth of field that, in this particular situation, would have been undesirable. Many portrait photographers never work with a lens shorter than an 85mm, while a 105mm and a 135mm are also popular. It's rarely necessary to choose anything longer than this because you won't generally be working too far from your subject, and you'll also find that these longer lenses will introduce such things as less than generous maximum apertures allied with camera shake.

 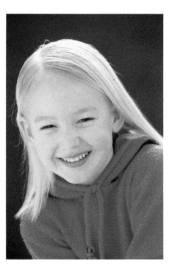

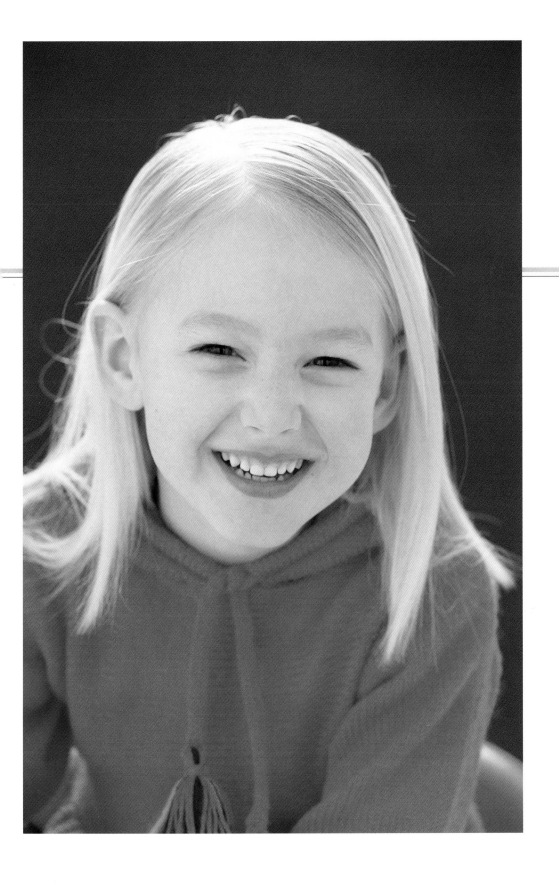

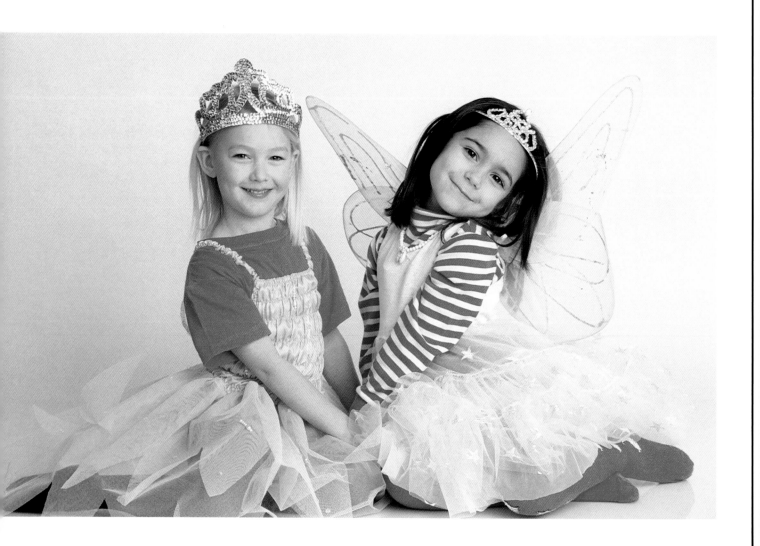

When you move up to featuring two children in your pictures, you don't necessarily double the problems. A well-matched pair will play off each other, and could make your task as a photographer much easier, especially if you make the session fun for them.

Children are normally animated when spending time with those they are comfortable with, such as brothers, sisters or friends.

They are also capable of some of the least self-conscious and natural poses. Here the photographer has set up a simple two-person arrangement, one which, although it looks extremely straightforward, is actually harder to master than it appears. Instead of positioning the children face-on to the camera position, which would have looked far too contrived, the photographer has asked them to adopt a three-quarter position to the camera, and then set up a livelier feel within the picture by asking the pair to react with each other. The tilt of the girl's head has made the shape of the portrait far more dynamic, while the contact that's now made between the two immediately adds warmth and intimacy to the picture.

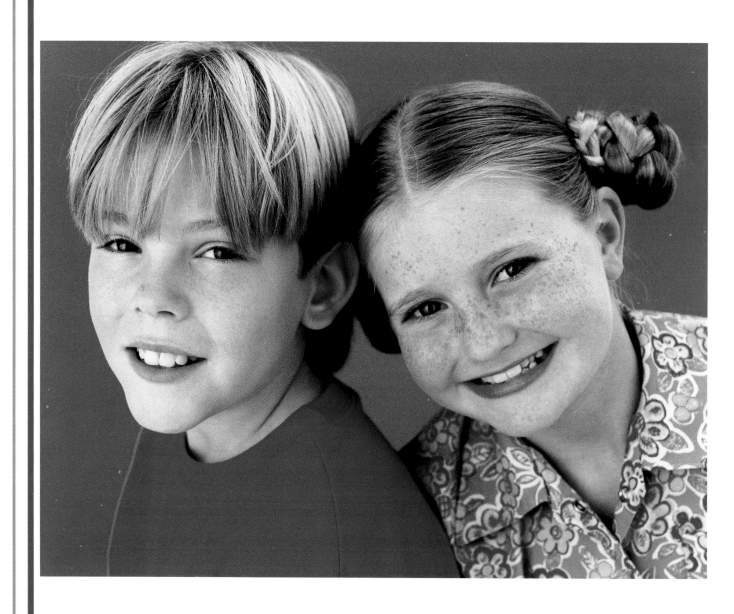

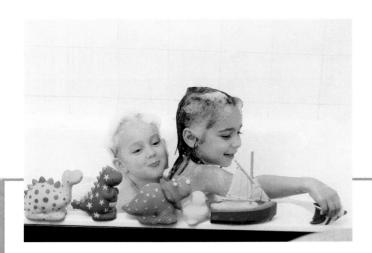

The art of creating a situation in a controlled studio environment is to make it believable, both to the viewer and the children themselves.

Technique

The props help to give the scene a touch of realism, while the suds in the hair add a vital touch. Photographing this scene in the studio gives the photographer the kind of control that a location shoot wouldn't allow and, as can be seen here, it's not necessary to go to the trouble and expense of building a full-scale set. All that's required is the suggestion of the real life situation, and the viewer's imagination does the rest.

It is, of course, possible to work on location as well, but you'll need to find a bathroom that's big enough to allow you to work plus, of course, you'll need to take particular care to keep any studio flash that you're using well away from water. Backgrounds and general surroundings on a location shoot can also pose problems: in a studio you can control these elements, but if you go on location you'll need to check carefully that everything that is going to feature within the frame is clean and without blemishes.

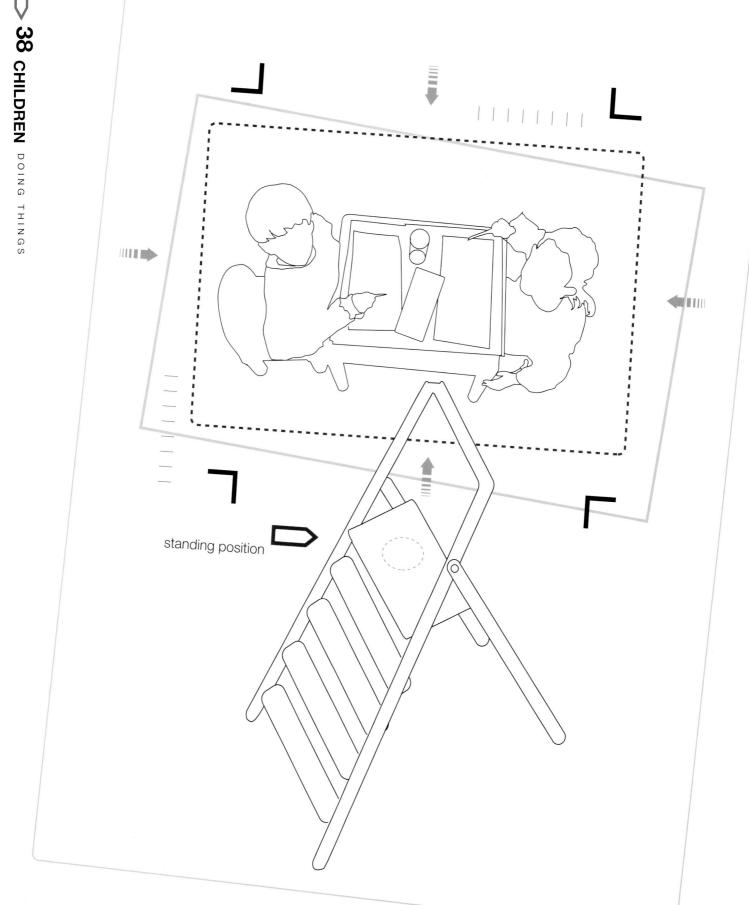

standing position

Children's sense of liveliness is similar to that of toddlers, though often in a more predictable way. Their activities tend to be more organised and with the presence, participation or guidance of a parental figure, planning photographic set-pieces should therefore be easier, especially if the photographer also happens to be the child's parent.

Composition
This set-up image (the photographer was perched on a ladder) echoes a natural situation. Looking down from a high viewpoint enables the viewer to see the children's handiwork and includes it as an element in the composition.

Lighting
The large source lighting, via a softbox, comes from the lower right-hand side of the frame. The white backdrop acted as a large reflector.

Colour
The image forms a pleasing whole, with the red colour helping to bring together the different picture elements.

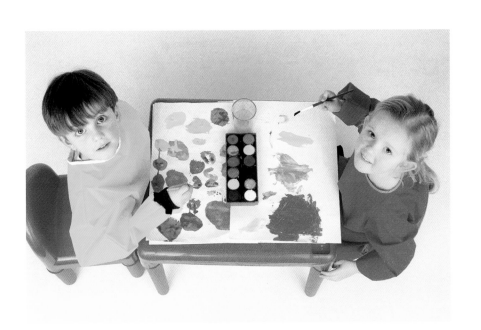

Children love to dress up and to play adult roles. Encourage their imagination and you'll benefit with some fun-filled images.

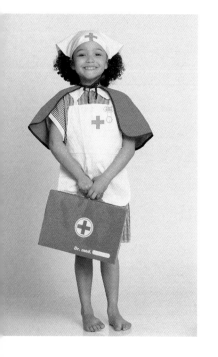

Technique

Children have a wonderful imagination, and love to act out pretend situations. You can encourage this by borrowing a selection of clothes that they can wear, and then allowing them to make up their own stories about them. A studio session like this needs to be relaxed and to have plenty of time built in, because it often takes time for things to start to gel, but eventually the children will almost forget that there's a camera around and will be at their most natural. You can also be sure that they're unlikely to get bored too easily, and ultimately this will give you a lot more time within which to work.

Lighting

A large softbox was used as the main source of illumination for this picture. The gentle and even light that this creates gives the photographer maximum flexibility. The light is flattering to children's soft skin, and because its spread is usually fairly wide it allows the subjects some degree of movement within the studio without the need for the light to be readjusted. It's rare that lighting needs to be more complicated than this: children seldom benefit from dramatic lighting effects, and the natural approach usually carries most appeal.

Composition

Involvement in such a world can sometimes produce a new set of poses or, as here, a make-believe formal pose. The photographer has pulled back a little, making the clothes, not the faces, the main focus of attention.

If you want to relate to your subjects, it's important to be on the same level as them and not to be looking down on them from a typical adult's height. It's friendlier, less intimidating and allows the children to dominate the frame more. The photographer can either set the tripod as low as it will go and then work either behind or to one side of it, or the studio set could be arranged on top of a raised platform, so that the children are naturally brought up to a more suitable height.

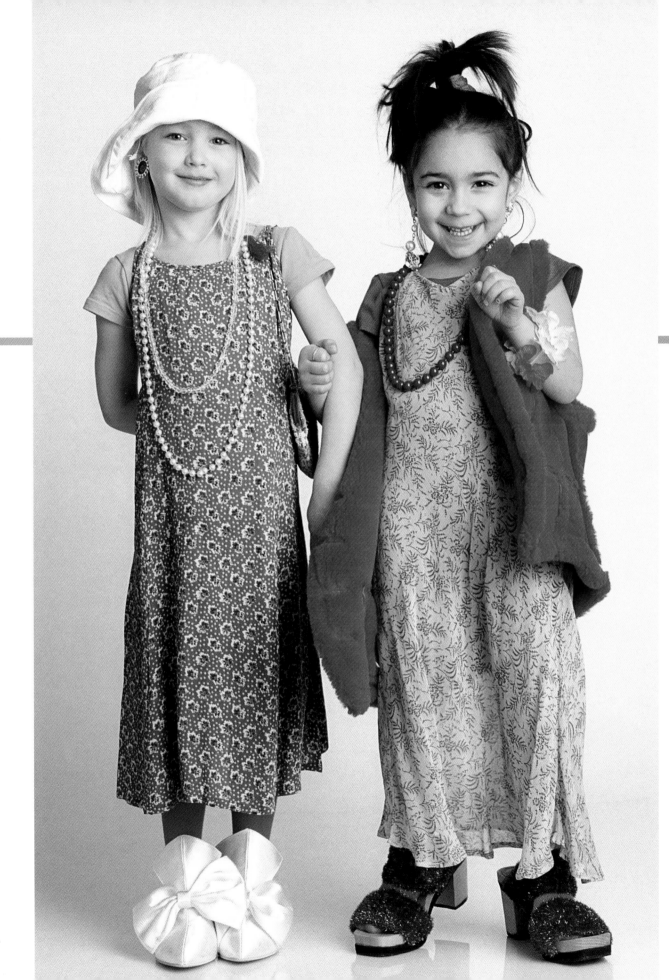

technical details 150mm telephoto lens on a medium-format SLR. Film used was Ilford FP4 black and white.

Props

Props can perform several roles for the photographer. They can serve as inspiration for a pose or a theme within the picture, they can be a vital element of the picture itself or they can simply serve as something that interests and stimulates the child and makes them more involved in the picture. They don't need to be complicated: here a simple spray of flowers has added the final touch to this portrait of a thoughtful little girl. It's given her hands something to do, and has complemented perfectly the outfit that the girl is wearing. The chair, too, is a prop in this picture and it serves to provide scale and to make the girl, perched high up on the seat, appear more vulnerable. Notice how well the chair has worked in this picture despite the fact that it's a bit tatty. Props don't necessarily need to be pristine – in fact they will often work better if they appear a little careworn. It gives a more natural feel to the picture and makes it look less contrived.

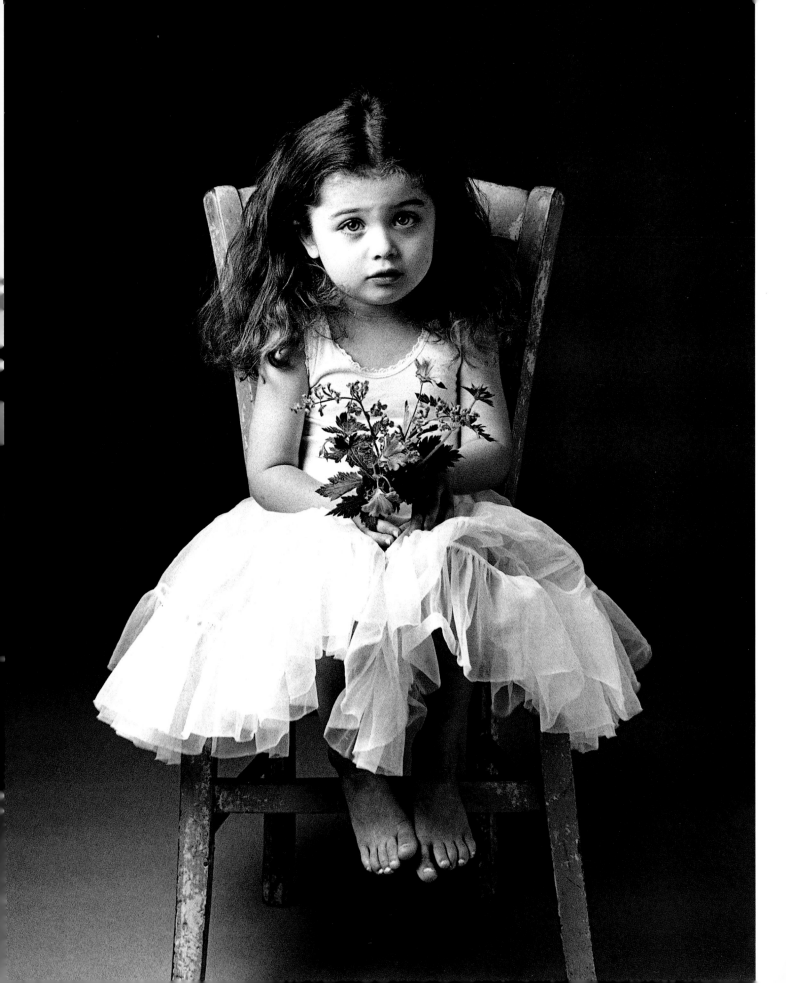

The active and often unpredictable antics of children present problems, as well as opportunities, for the keen photographer. Fast-moving little ones can offer good practice for the would-be action or sports photographer.

Opportunities to photograph this subject matter occur at school, as well as at less formal events such as parties or outings. The photographer/parent can use such occasions to record and chart their child's development with children other than their immediate family and friends.

Lighting

Fill-in flash is one of the photographer's most useful techniques when photographing children outdoors. Here, on an overcast day, it's been used to lift the shadows that existed on the faces of the children. The photographer simply fits on-camera flash and then adjusts its intensity downwards to a point where it will be able to lift the exposure at close range by around one stop, but won't be so bright that it affects the rest of the scene. Used properly, this technique should be virtually undetectable: if faces appear far too bright, then the ratio of flash and daylight has not been judged properly. See page 100 for more detail.

Composition

The tree branch is a useful prop, keeping the children's hands occupied and also holding in the different elements of the composition. The image perfectly captures the exuberance of children at play.

Colour

The busy colours and patterns add visual interest, and are strong enough to counteract the red of the children's clothing.

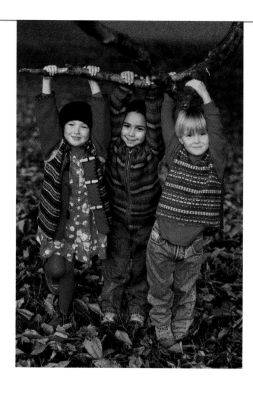

A zoom or telephoto lens is a must, as it helps to isolate the children from their surroundings, and create a less intrusive distance between them and the photographer.

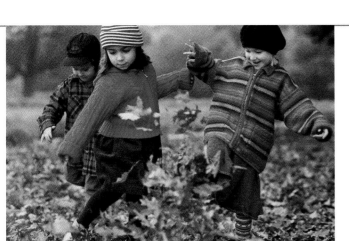

Outdoors is a great place to photograph children, and the possibilities for action photography are virtually limitless. Look to use natural props, such as these leaves, and create a game from the photo session. To an extent everything here is controllable: you can ask the children to start playing at a given command, and will know where the action is going to take place, but, as with any kind of movement in a picture, there are certain elements that are unknown. As arms wave around, for example, you might find that one of them obscures a child's face, or you might find that eyes are closed or expressions aren't right. The only answer is to take plenty of film, and to set the picture up several times until you're sure that you've got what you want. Don't be afraid of some movement in your picture. Action studies aren't necessarily meant to be frozen in every area, and a shutter speed that allows a little blur to register in the leaves and perhaps around the feet will only serve to emphasise the boisterous nature of the game that's taking place.

"Sometimes you wait for a second and you catch it, at other times you stalk for hours."

Henri Cartier-Bresson

Lighting

The picture was lit with two softboxes, one either side of the photographer and directed at 45 degree angles towards the subjects, almost in the style of a copying set-up. Behind the children a further two lights were directed on to the background to ensure that this was bright enough to record as a pure white with no tone to act as a distraction.

Technique

This well arranged tangle of children was no happy accident. It was a situation that was contrived by photographer Gerry Coe as a way of showing the three children of a neighbour's family in an informal group. "I wanted to come up with a fun shot," says Coe, "so I asked the children to tumble down into a rough group, and then I directed it a little from there. The youngest child, who was two, fell over and I got the older boy, who was six, to put his arm around him and to hold him in the picture. All three of them were laughing and having a great time: their mother just saw everything falling apart, but from my position by the camera I saw it all falling together. I simply encouraged them to form a group and took it from there. I got six pictures in total of this scene, and that was it."

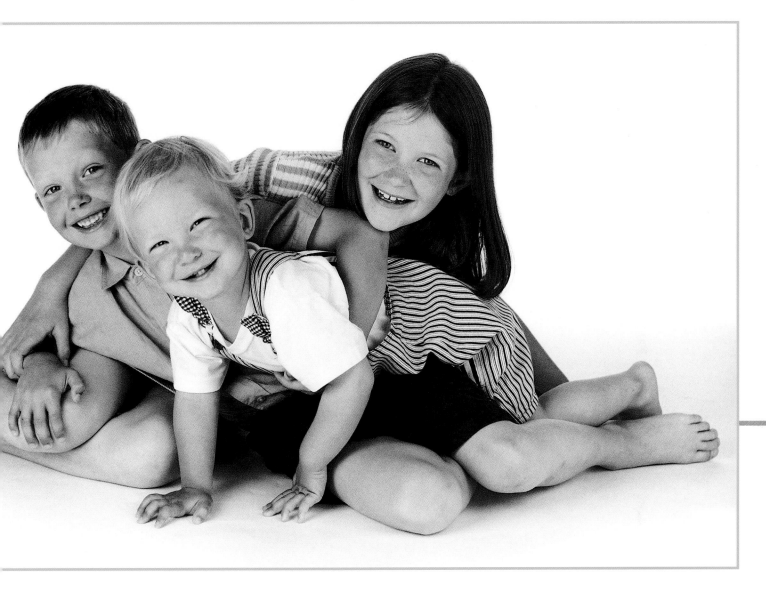

Composition

What started as a muddle of bodies ended up as a pleasing and remarkably informal picture. From his position next to the camera Coe saw his composition coming together. He directed so that heads were separated and that hands and legs were arranged as gracefully as possible, and he accepted that, to some eyes at least, the result he achieved might be considered slightly messy. "Some photographers tell me that the children aren't sitting together in a particularly pleasing way," says Coe, "or that they don't like the way that the hands are arranged. I don't care what any of them say, because I think the picture has the most important element of all. It's got life."

Most children pose easily for photographs but when they're in an animated mood the photographer needs to work quickly. Such an approach and the right timing can yield spontaneous and lively pictures.

Bright, overcast daylight is ideal for outdoor portraiture. It provides virtually shadowless lighting, and is the natural equivalent of well-balanced and softened studio lighting. The picture here also benefited from a touch of fill-in flash, just to lift the contrast a little and to highlight the girl's face. The picture is obviously contrived to a certain extent – the child has been asked to pose and to lie still, and has then been covered with autumnal leaves – but still the image has great charm, and the cheeky smile of the child looks unforced and attractive. The red of the jumper and hat surrounds and frames the face. Red is also an autumnal colour and combines successfully with the colours of the leaves.

Technique

Different camera angles and viewpoints give fresh compositional ideas for the photographer to exploit. Here, a superwide lens of around 17mm, has been used to create a dramatic pose: the photographer has laid the camera on its back on the ground and has fitted a cable release to the shutter release. The children have then gathered together and looked directly down on to the camera for maximum effect. The angle of view supplied by a lens this wide gave the photographer the reassurance that all his subjects would be in frame, and the depth of field was such that focusing was never going to be an issue.

Composition

Once the photographer has arranged the technicalities, the children's expressions still need to be in keeping with the happy and relaxed feel of the picture. Once again it comes down to making the picture session fun: this kind of set-up can capture the imagination of children, who see the whole exercise as a huge game, and react to the camera accordingly.

Bending the rules of composition, and thinking laterally about camera viewpoint, creates a look that is strikingly different, one that will have far more visual impact than a conventionally posed image.

Lighting

From this angle, a straight picture would have suffered from the shadows that inevitably would have obscured the faces of the children. To overcome this, the camera was fitted with a diffused flash that created a burst of soft light as the exposure was made. It was enough to lift the shadows while still leaving the result looking natural.

Superwide Lens

The superwide lens is one that offers an extreme angle of view without much of the distortion that once was associated with lenses of this focal length. Like all wide-angle lenses it will emphasise the relative sizes of those subjects closest to it, but it features none of the curvature of field that once was such a trademark of this kind of lens.

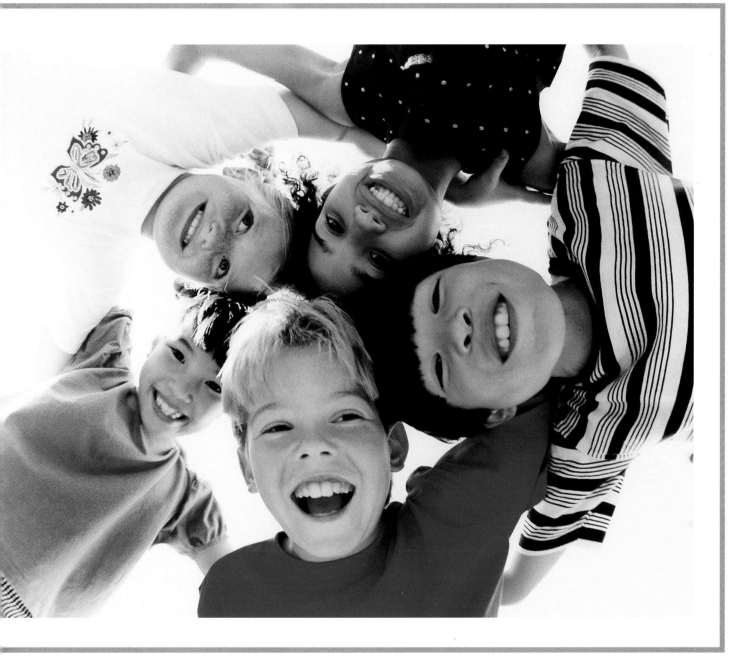

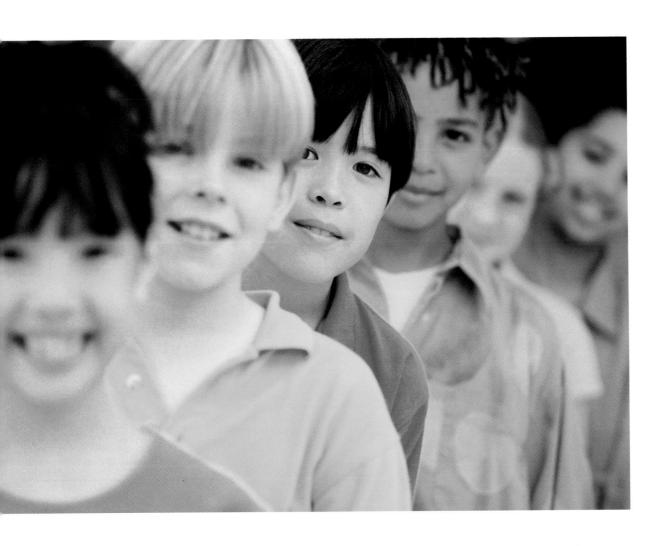

Technique
The photographer placed these children in a line and framed them with a telephoto lens. He knew that the perspective-flattening characteristic of a telephoto would produce this result, making the children appear closer to each other than they really were.

Lighting
This picture called for a large area to be lit evenly, and the solution was to utilise a large softbox and to spread the illumination around further by the use of free-standing reflectors, which were adjusted to throw the light into any shadow areas and to lower the contrast.

Composition
This was a picture that required precise direction from behind the camera. The line of children was set up at a slight angle and then it was up to the photographer to position each of his subjects so that just enough of the face of each of them was visible for the picture to work. By using the maximum aperture on the telephoto lens, very narrow depth of field was created, which was then checked visually through the viewfinder of the SLR used. To increase the impact, the picture was then cropped tightly to exclude any foreground or background details.

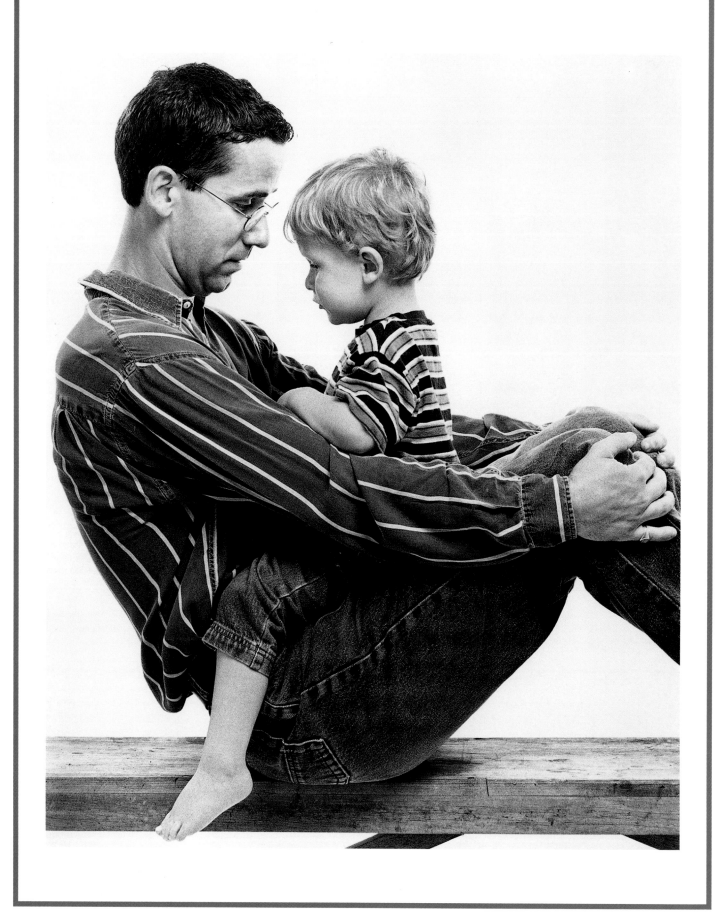

Lighting
The background was lit by two studio flashes on either side. A boom arm with a softbox was placed above the subjects and closer to the camera.

Composition
The photographer positioned the father and son on the bench. After making sure that they were comfortably seated she let them choose a pose. Though the set-up was pre-arranged the result looks like a real-life moment.

Technique
The lighting and set-up was chosen by the photographer to give a bright, easy-on-the-eye result. The father wanted this photograph to be a birthday present for his wife.

3

As children grow into teenagers, the challenge to the photographer is to capture something of this transitional stage without resorting to clichés. Look to achieve more input from your subject's developing personality

Lighting

The illumination on the face is provided by two softboxes, one either side, which are positioned just 18 inches from the subject and operated at around half power so that the intensity of the light is not overpowering. Two further lights, used at full power, are positioned on the background, so that this is completely washed out and all tonal detail there is removed. Finally, to even up the lighting on the face still further, Coe uses a Triflector – a reflector that is hinged in two places so that it can be adjusted more precisely – under the chin of his subject to throw light back up from the floor.

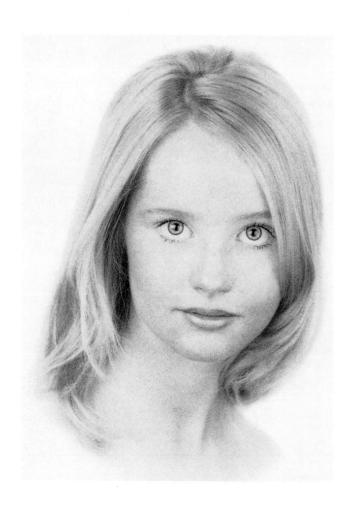

Technique

It looks like a pencil drawing, but this in fact is a photograph by photographer Gerry Coe that has been lit and printed to achieve the feel of a work of art. "I aim for a high-key effect," says Coe. "I use a white background and light my subject brightly and then overexpose by up to two stops so that the negative I achieve is quite dense. In the darkroom I can print this so that I could, if I wanted, achieve no texture on the skin at all, although most clients like me to print a little darker than this, to allow just a little of the tone to come through. The nature of the print highlights the facial features, particularly the eyes, and smoothes out any blemishes that the sitter might have."

Printing

The final stage in the production of a Pencil Print is to print the result onto Kentmere Document Art paper, which gives the picture a textured and more painterly finish. It can take up to ten attempts to achieve a look that has the right tonal appearance, even for an expert printer like Coe, but when everything works the effect is so powerful that many are fooled into thinking that this is, indeed, an artwork rather than a photograph.

High-key lighting can prove extremely flattering to a sitter, and can even help a picture to ultimately resemble a work of art.

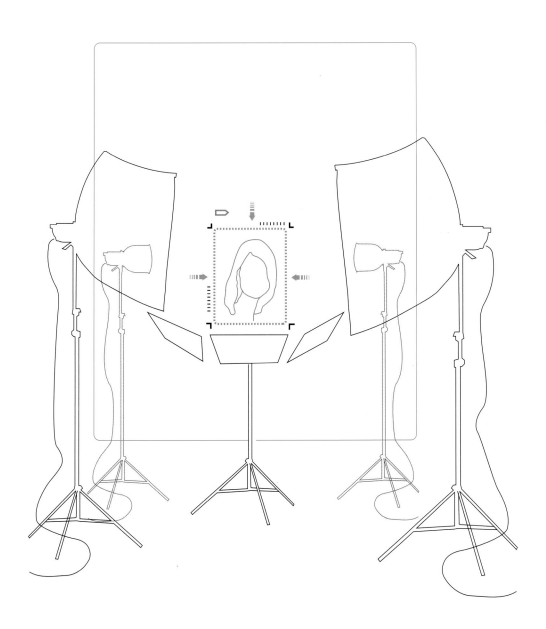

A reflective moment captured on a photo shoot. A low viewpoint and deliberate tilting of the camera to create a crazy lopsided horizon has broken all the compositional rules, but added extra spice to what could have been a rather ordinary study. The girl's pose, leaning back slightly

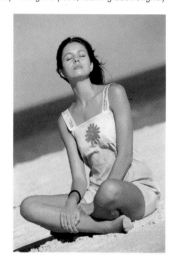

with eyes closed, has suited the lighting, which is harsh and coming from a position almost directly overhead. Had she tried to look at the camera, she might well have been forced to squint with the intensity of the light, but here she can pose comfortably and yet still look natural and relaxed.

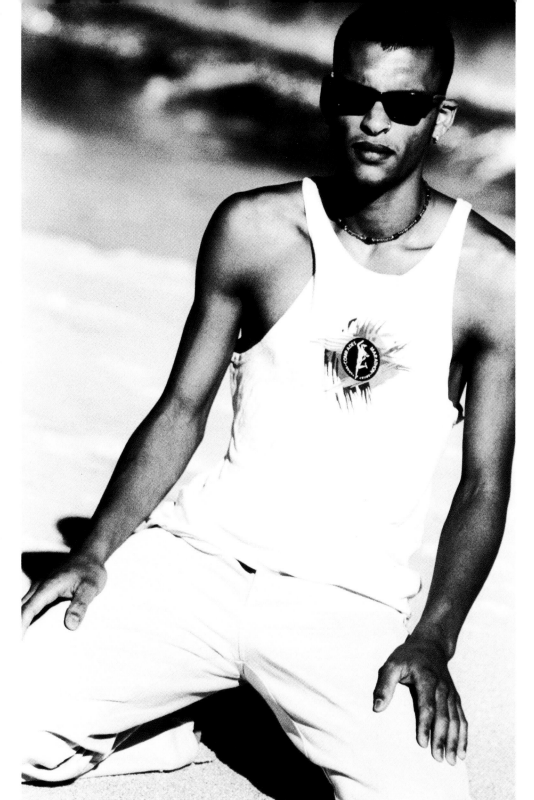

Lighting

Another way of dealing with harsh midday sun is to ask the subject to wear sunglasses. Since these are items that are associated with attitude and the teenage lifestyle, you shouldn't have too much trouble persuading your subject to pose with a pair and, like every good prop, they may well impose a certain look on your subsequent pictures or even lead to some new ideas and poses being tried out.

Composition

Once again the horizon has been tilted, and it's all part of the fresh, lively and different approach that so often characterises photography of young adults. As a photographer this is your chance to try something different and brash. Look to feature bold shapes and colours in your images, and don't be afraid to frame so tightly that elements of the picture are cropped out. Anything goes in portraits of this kind, so long as the results are exciting and full of life.

Technique

Toning has reduced this image to a single colour. The technique has emphasised the shape of the subject and the contrast of the lighting. The hue makes an interesting alternative to a conventional colour image.

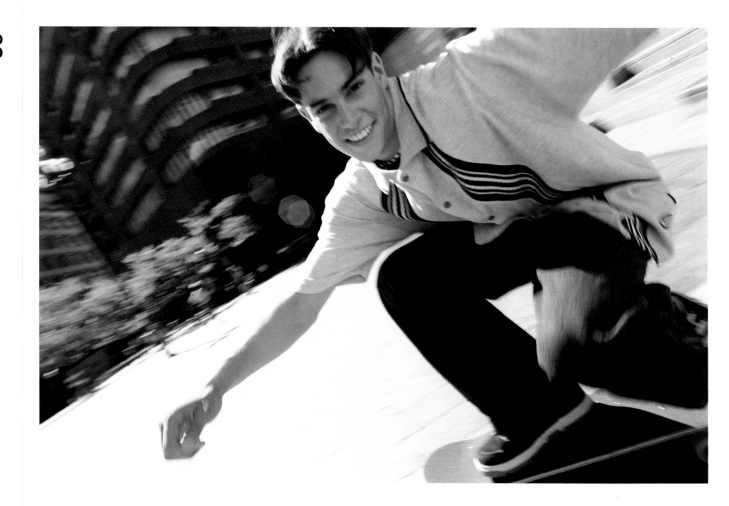

Teenagers lead active lifestyles, and if you want to present an accurate portrait of your subjects at play you have to develop skills commonly associated with a sports photographer.

Pride in new-found physical skills is another teenage characteristic. Very few will mind a photographer recording a new trick, especially one that may have taken a lot of time and practice to achieve.

Technique

High-speed action requires film fast enough to allow the use of the shortest shutter speeds. A film with an ISO rating of 800 can feature the same low-grain quality you would have found in an ISO 100 film not so long ago, and these modern materials usually have the facility to be pushed as well, to gain you still more speed. Pushing a film simply means that you've rated a film at one or more stops above its nominal rating. You're effectively underexposing, and so to compensate you'll need to increase film development. Most laboratories have a facility to do this or, if you're processing your own film, the manufacturer should be able to advise on extended development times. Push an ISO 800 material two stops and you'll have an ISO 3200 film, which will allow you to freeze virtually any action you come across, even on a dull day.

Other aids to help you capture fast action include a continuous wind facility on your camera to allow you to keep the camera to your eye, a good auto-focus system so that your focusing will keep pace with the action, and fast shutter speeds and lenses that feature generous maximum apertures.

Panning

For all the technique one learns about action photography, there are also occasions, such as this one, where the photographer can adopt the opposite approach and can choose to select a shutter speed that is slow in the hope that the blur which will be achieved will better convey the sense of movement and speed. The theory is simple enough, but it will take a fair amount of practice to achieve success. If you set a shutter speed of around 1/30sec, and then swing the camera in the direction the subject is moving as he passes by you, by timing the swing correctly you should be able to retain some degree of sharpness in your subject. The camera's movement will have blurred the background, however, since this obviously has remained static. The example here is fairly mild, but a more extreme swing on a subject, such as a racing car that is moving at high speed, will reduce the background to a series of parallel streaks, which can be highly effective.

It takes time to master the speed of the swing, but practice will achieve results. Don't get hung up on the idea that the whole of the foreground subject needs to be pin-sharp. A little blur, as seen here in the arm and the leg of the boy, only adds to the drama. More on panning can be found on page 118.

Composition

Everything about this picture says speed and adventure: the wild angle the camera has been held at, the blur in the background, the look of excitement on the boy's face as he flies by. Fast reactions have been called for to capture this moment on film: the easier option would have been to use wider framing enabling the whole subject to be included, but this would have removed much of the intensity and drama from the picture. Instead, the photographer has waited until the boy was just a matter of a foot or so away and has filled the frame with his subject. The fact that there are parts of the boy's body that have been cropped out through this approach matters very little. Often it's not what you can see in a picture that counts, but the atmosphere that you've managed to capture within it.

Technique

While traditional portraiture is best undertaken with a medium telephoto lens, when you're looking to record lively and strikingly different portraits of teenagers you may find that a wide-angle lens, with its ability to distort and to emphasise those subjects closest to the camera, will offer you something more interesting and contemporary. These confident subjects were happy to co-operate with animated expressions and, by moving in close, just a couple of inches from the middle of the three girls, the photographer has been able to create a picture that's fun and full of life. The full effect of the wide angle will only be seen when subjects are right in front of the lens: just one step back would have diluted the image and destroyed the impact.

Composition

The main thrust of the composition, and one that has worked brilliantly, is the way that a feature has been made of the middle girl's tongue stud. The placing of the girl, and the use of a wide angle, has ensured that this has been emphasised and made into a central feature of the picture – suddenly we're given a storyline for the image. The laughter of the girl on the right, watching her friend show off her daring jewellery, speaks volumes about the camaraderie that exists between girls of this age, and the closeness of the three heads further highlights their strong relationship.

Lighting

This picture was taken at midday when the sun was high in the sky. The photographer has positioned his subjects so that light is coming slightly from the side and is throwing the main shadow down on to the bodies of the girls, where it's at its least distracting. It's also ensured that the girls aren't squinting with the sun directly in their eyes, while the strength of the partial side-lighting has provided good modelling to the faces, making these subjects appear almost three-dimensional.

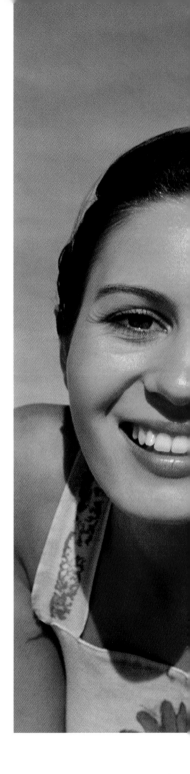

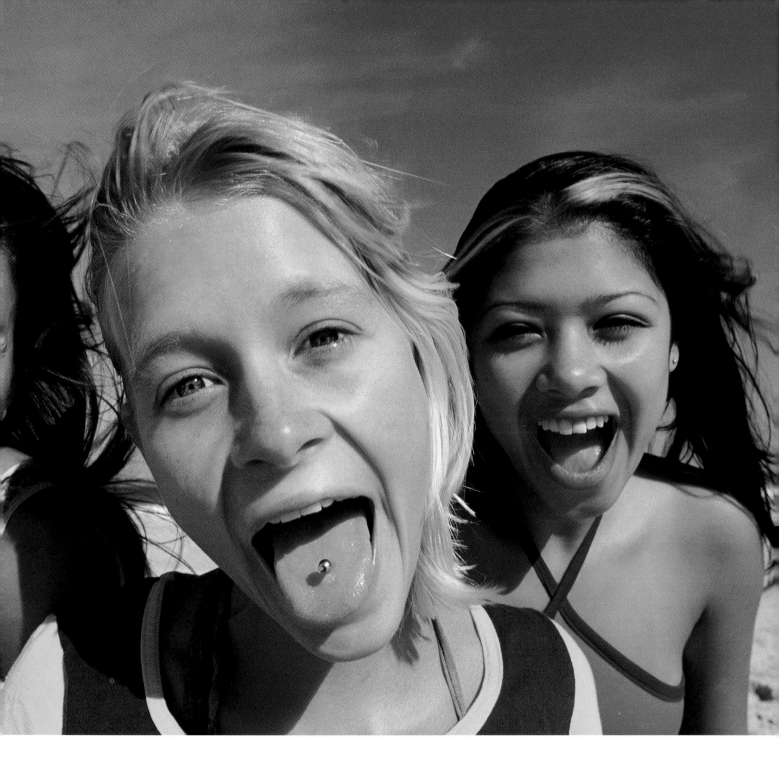

The distortion a wide-angle lens will offer when used at close quarters can produce brash and contemporary teenage portraits.

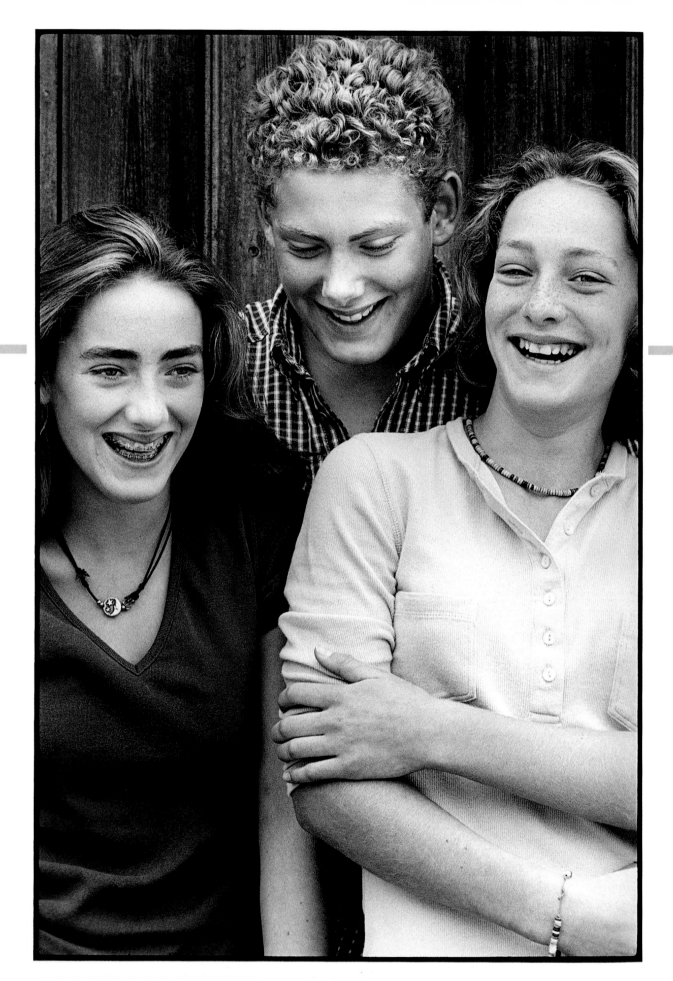

The photographer took up a low camera-angle here, and shot from a distance of around 15 feet using a 135mm telephoto lens. This moderately long lens has delivered characteristic compressed-perspective, and brought the three subjects apparently closer together in the frame. It's also served to smooth out facial features so that the result is more flattering.

A good portrait photographer works hard to establish a rapport with their subjects. People are nervous in front of the camera, and talking and helping them relax will create the right atmosphere for natural-looking portraits.

Composition
The photographer has taken good note of the relative sizes of these triplets, and has positioned them accordingly. The tallest of the three has taken up the central place, while the two sisters have been placed on either side so that the three heads make a pleasing triangle shape. Asking all three subjects to look directly into the camera would have made this a very formal portrait, which would have been entirely the wrong mood to create for teenagers. To combat this, the photographer talked to her subjects and encouraged them to relax, and then shot pictures at moments when she thought the composition looked interesting. This is one of the most successful images from the session, and it can be seen that the usual rule that dictates eye contact between subject and photographer is sometimes best broken. Even though the boy is looking down we can see his smile, and the overall feel that's been created is one of a strong bond existing between the three.

Composition

This is a picture made powerful through the bold placing of the three subjects. The boys have been posed carefully, and their relative heights adjusted so that the three of them take up the classic triangle shape within the frame, while none of their heads have been allowed to overlap. A wide-angle lens has allowed the boy in the foreground to dominate, and his lack of expression and cool shades convey attitude. The other two subjects echo his look and style, and there's a strong feeling of symmetry in this image, emphasising the closeness of the relationship between the trio. A savage crop down the right- and left-hand side of the frame tightens everything up and adds to the brash nature of the image, while one highlight has been allowed to reflect from the sunglasses on the left. This creates a point of interest in this area of the picture, and adds a touch of glamour.

Lighting

Bright directional light has been used to great effect here, with the intense shadows that have been created adding modelling to the faces and giving them extra strength. The brightness of the lighting makes sense of the sunglasses and the bare torsos, while the suggestion of a beach behind the three completes the summer feel. The sunglasses, of course, have also allowed the photographer to direct his subjects to look towards the light source. Normally this would have been extremely unflattering and would have resulted in eyes being screwed up against the sun, but here the glasses have protected the eyes and created a theme for the picture.

Cross-processing

A simple way of adding a slightly unreal touch to the image, and one that's been heavily used by fashion photographers over the past few years, is to cross-process the image. This simply means that transparency film is processed in negative film chemistry to create abstract colours. The reverse technique – the processing of negative film in transparency film chemistry – can also be used to great effect. Experimentation is the best way to explore what these procedures can offer and, although it's difficult to predict with any great certainty exactly what effect you will achieve, that's part of the appeal of this simple technique.

Technique
The photographer used a shallow aperture with his telephoto lens so that the background with its areas of speckled highlight would become out of focus and non-intrusive. The telephoto lens has also isolated the girl from any distracting foreground details.

Lighting
The primary light source for this picture is the sun, which is coming from a position directly behind the girl. This has allowed it to pick out highlights in her hair, and it's ensured that she hasn't got to screw her face up against harsh direct lighting. It did, however, mean that her face was in shadow, and some frontal lighting was needed to reduce this effect. Fill-in flash, from a source positioned to the right of the camera, was used to create a better balance. Its effect is so subtle that its appearance is completely natural looking.

Composition
The photograph appears to be spontaneous but it has been cleverly arranged. The girl is looking at someone outside the frame and the suggestion is that she is in the middle of a conversation. And the tilt of the image adds another element of visual interest.

Harsh sunlight can be used for a portrait, but the subject should be positioned so that they're lit from behind, with shadows on the face lifted by fill-in flash.

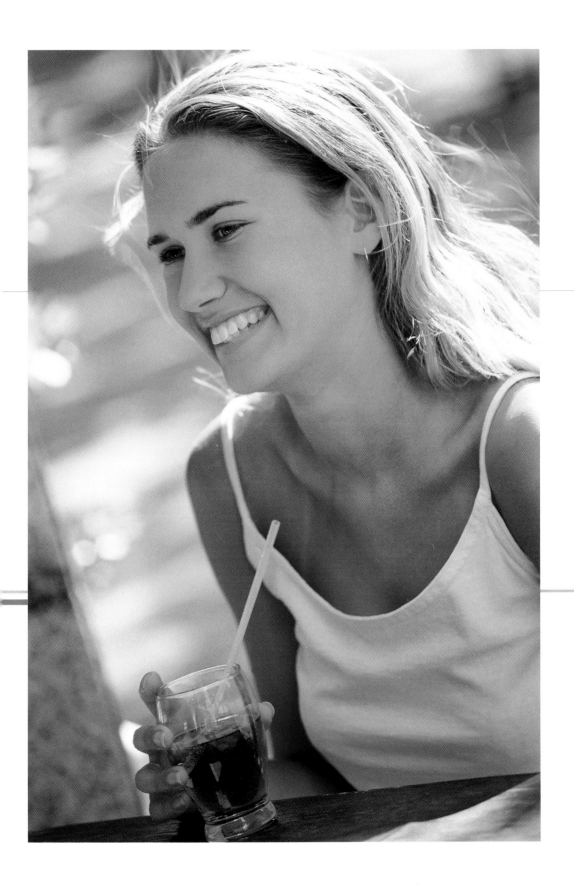

Lighting

A straight studio flash, placed at the left of the camera, was aimed at the foreground seated subject. A second studio flash with a red gel, positioned just outside the frame at the left and across the studio floor, was pointed at the girl. A third light, with a blue gel, was pointed at the background figure. Meanwhile the third figure was lit by a large, diffused light source reflected off the ceiling.

Composition

This composition was carefully designed and carried out. The figures are together but they don't overlap each other. The arrangement links all three and brings to mind an album cover.

Technique

A very shallow aperture has ensured that while the foreground figure is sharp the other two are out of focus. The flash with the red gel had to point across the image to avoid spillage from the red gel's illumination onto the background. It was intended for the third figure, at the centre, to blend into the blue background.

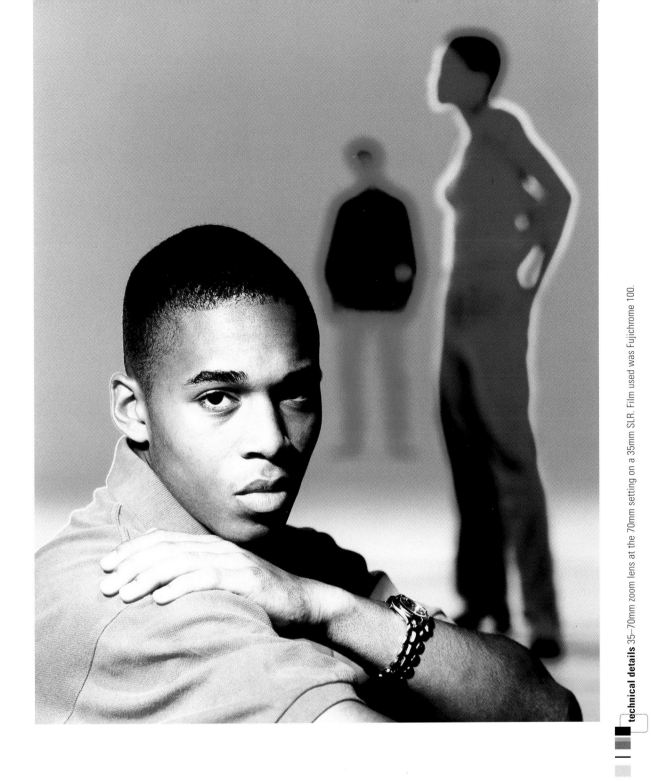

technical details 35–70mm zoom lens at the 70mm setting on a 35mm SLR. Film used was Fujichrome 100.

"A portrait is not a likeness. The moment an emotion or fact is transformed into a photograph it is no longer a fact but an opinion."

Richard Avedon

Lighting
Two softboxes were positioned either side of the subject, about two and a half feet away. A special silver reflector with three adjustable separate segments was used to throw light back into the girl's face.

Technique
The photographer shot down at the girl, and asked her to lift her eyes up towards the camera. The actual reflection of the two softbox lights can be seen in her eyes, which adds to the intensity of her gaze.

Composition
The photographer asked the girl to clench her hands so as to hide her fingers, which would otherwise have been a visual distraction so close to the face. The hands also act as the base of the frame created by the girl's hair.

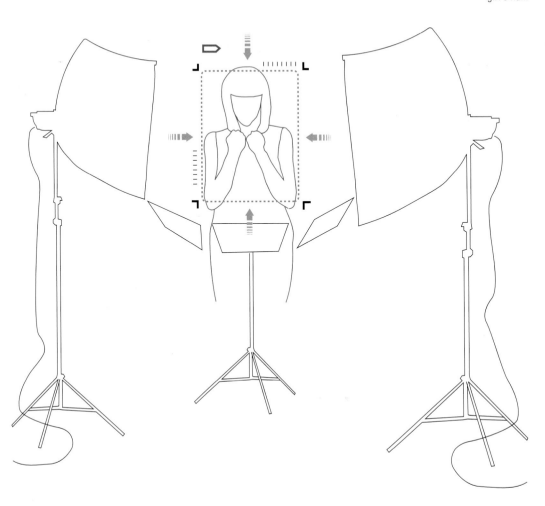

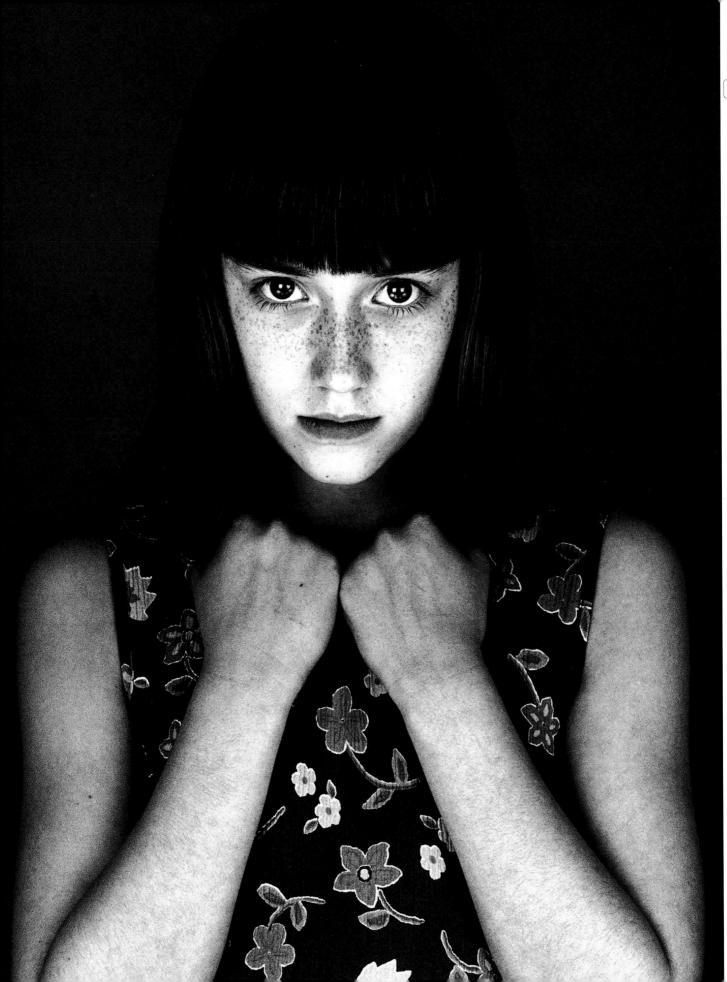

couples

4

With couples the photographer should try to convey through composition and posing something about the

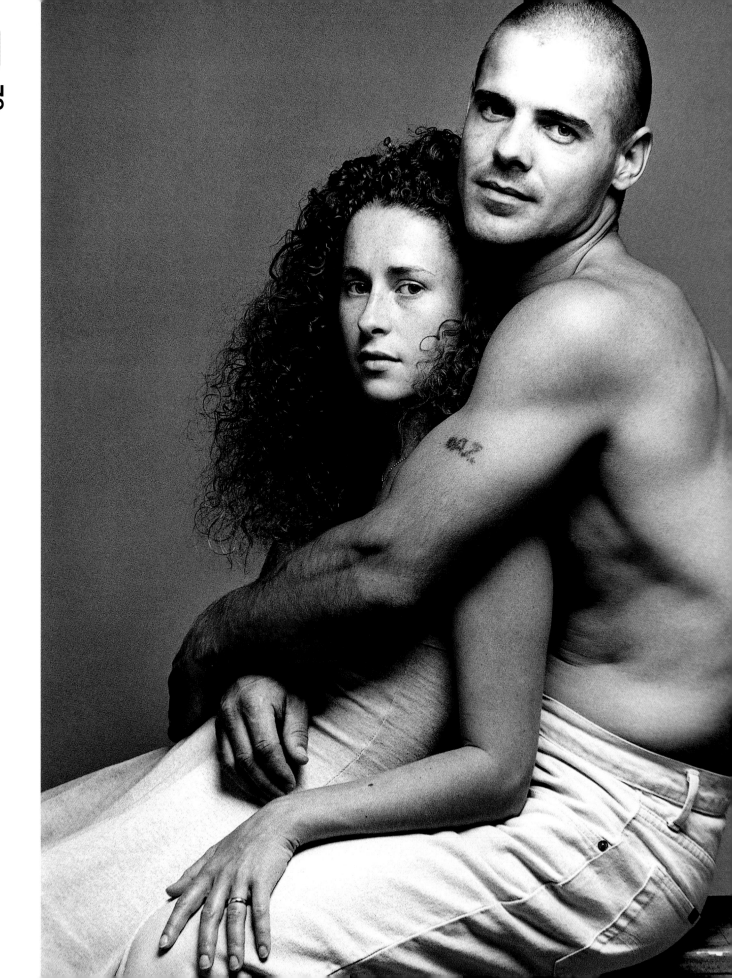

technical details
Medium-format SLR
camera. Film used was
Ilford FP4 black and white.

"I always use a single light if possible. My motto is 'keep it simple'. If it gets too complicated it takes away from what you're photographing. It just becomes an exercise in lighting rather than what's in front of the camera."

David Bailey

Composition

The heads of the couple are close together but on different levels, creating a far more dynamic pose than would have been possible had they been side by side, while the arms of the man wrapped protectively around his wife also helps to put across the idea of a warm and loving relationship. The angle of the man's left arm and the tilt of the bodies also helps to ensure that the sweep of the picture is along a diagonal line reaching from bottom left to top right, which provides a very geometric and stylish solution to what, potentially, was a challenging compositional problem.

Technique

Although a softbox, by its nature, will generally provide a gentle source of light, by using just the one and positioning it so that the angle it was coming from was high above the couple, the photographer has created strong modelling on the faces, and deep shadows around their bodies. It's also meant that little of the light has been able to spill on to the background. Had this received frontal lighting it would have recorded as a light grey, but because little light has reached this point it's become much darker, an effect that has helped to emphasise the subjects.

Technique

Shooting into the light can produce wonderful results for the portrait photographer. Strong back-lighting will create a bright halo around the head of subjects, known as rim lighting, while leaving the faces in plain overall shadow. Sometimes the picture can be shot, as here, in a straightforward way, a meter reading being taken from the face and exposure calculated for this point. This will ensure detail in this critical area, while the background may become a stop or two overexposed, which will only help to reduce its influence in the picture. If you feel that there's too much contrast in the scene for this approach to work, then you'll need to reduce the contrast by either using a fill-in flash or by employing a reflector. The latter technique has the advantage that it will show you the effect that you're going to achieve, and you can position the light that it throws precisely.

Lighting

This is rim lighting in action, created by light coming from above and behind the subjects, and it's easy to see why so many photographers love the effect that this gives them. The book the girl is reading has acted as a natural reflector, the light being thrown back up from its white pages.

Composition

By using a longer lens the photographer has been able to fill his frame with his two subjects while remaining at a distance to give them enough space to interact naturally. The foreshortening effect of this lens has served to pull the subjects away from the background, and to make this area of the picture appear far cleaner.

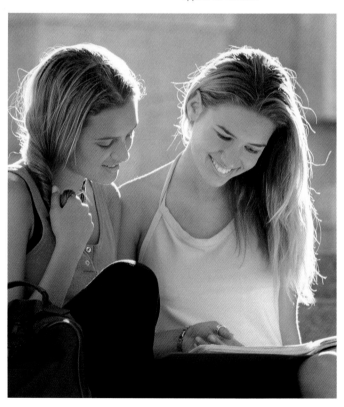

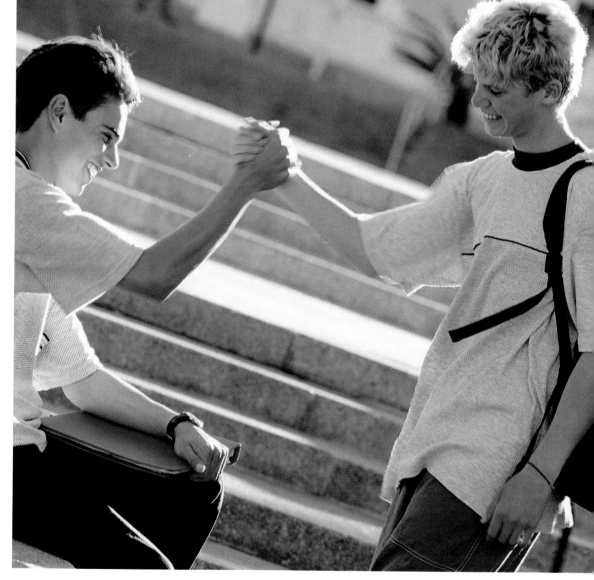

Despite the quality of the colour film now available, black and white can still be highly effective when used for portraits. This simple greeting between friends is given greater depth through the use of monochrome, and a simple twist of the camera to give the steps behind a tilt has added a dynamic edge to the composition. Once again strong back-lighting has created rim lighting, and its effect even in the absence of colour is still striking.

As a photographic subject teenagers are often at their best when they are interacting with a companion in a semi-formal or casual moment.

With two people that are comfortable in each other's company, relaxed portraits like this are easy.

Lighting

At such a close distance, even in bright lighting, the facial details would have been in shadow. A reflector has been placed very close to them, beneath their chins and aimed upwards. It has produced a glow in their faces and with their smiles creates a positive, happy and saleable image.

Composition

The positioning of the faces – side by side and close together – and the tight framing denote the closeness of the couple's relationship.

Colour

The couple's vibrant expressions shine out, while the fact that the film type used is black and white becomes of little importance. The image would have had similar impact if photographed in colour.

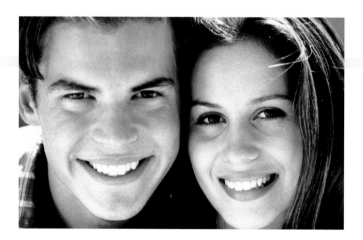

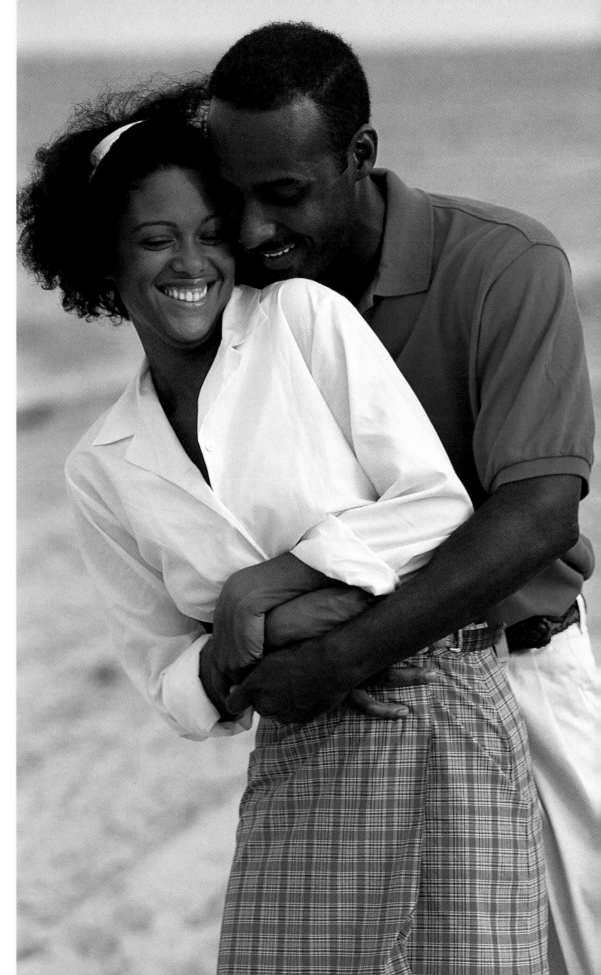

Mood

A couple in love will have moments when they have little awareness of their surroundings. At these times their body language reveals something of their feelings for each other. An aware and sensitive photographer can use these moments to produce rewarding images for all concerned. Use of a telephoto or zoom lens helps to keep a discreet distance from the subject.

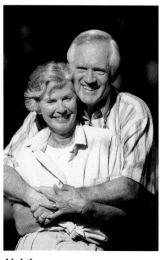

Lighting

This couple was lit with strong directional lighting coming from above and to the front, and the tight and compact shadows this has formed around the faces has revealed character without proving unflattering. Because the subjects are lit so strongly, it gave the photographer an option that has been exploited expertly. By looking for a suitable background that featured heavy shade, in this case a section of forest, it was possible to position the couple so that they were highlighted in almost a three-dimensional way. The technique can work equally well with a full-length portrait – when there's more visible

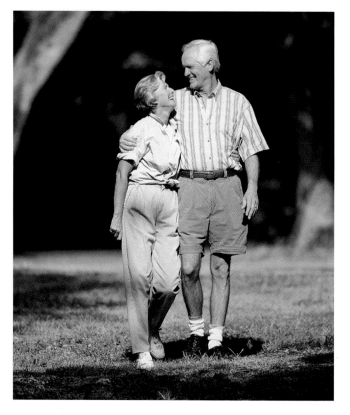

in the scene to put everything into context – and with a tight waist-up study – when it's been possible to crop in so that the shadow area forms the entire background.

technical details
35–70mm zoom lens at the 70mm setting on a 35mm SLR. Film used was Fujichrome 100.

The combination of strong natural lighting and a dark background can be stunning, whether the photographer decides to move in for a head and shoulders portrait or to pull back for a full-length study.

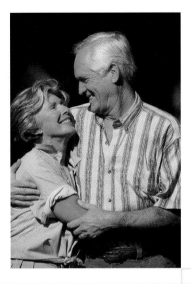

Technique

Outdoor portraiture requires constant problem-solving with regard to the control and modification of harsh lighting. Time of day is crucial. If direct lighting is required then late afternoon illumination is preferable because it is less harsh.

Lighting

By shooting later in the day the photographer will also be able to take advantage of the fact that the light will have become warmer, which often means that it's more flattering. This is down to what's known as colour temperature. Daylight-balanced film will be adjusted to give its best response in average conditions, but the light towards the beginning and the end of the day will be much warmer and further towards the redder end of the spectrum. Conversely, an overcast sky or shadow will tend towards the bluer end of the spectrum which, as far as portraiture is concerned, is invariably unflattering and therefore less acceptable.

Composition

The tilt of the heads and the different levels they take up in the composition gives the picture extra vitality, while the arm at the base of the picture creates strong framing.

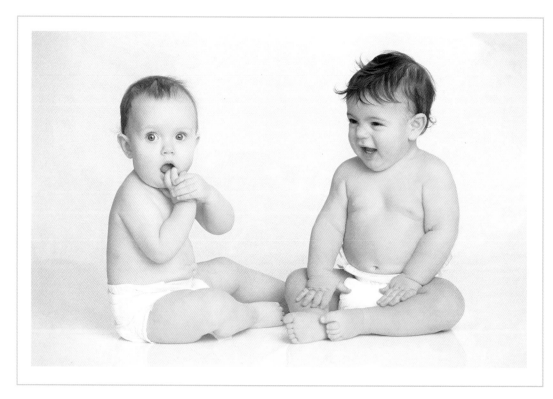

A softbox light source and reflective surroundings have eliminated 90 per cent of the shadows. Babies who have not yet learned to crawl are easy to position, though boredom and mood changes force the photographer to work quickly.

Composition

The attention span of a very young child is notoriously short, and so the subjects were introduced into the set at the very last moment. No one could predict exactly what would happen next, but in fact the children reacted well with each other, and the smile of the baby on the right, amused by the curiosity being registered on the face of his partner, was the pleasing outcome. Having two children in a set doesn't necessarily mean that problems are compounded: young children generally enjoy the company of others their age, and are more likely to react to them than they are to an adult.

Lighting

The softbox was positioned to the right of, and above, the camera. For such portraits straight studio flash is often rejected in favour of softbox lighting which has a more even spread of illumination.

Technique

The photographer knew this would be a tricky subject and planned ahead in some detail. All the elements, apart from the subjects, were pre-selected and tested. This saved precious minutes on the day of the shoot, enabling the photographer and the assistant to pose the unpredictable subjects!

As far as possible plan the set, lighting, camera positions and framing well in advance to ensure a successful shoot.

"I try to be quick so that the subjects don't notice. It's not that I feel any guilt, any sense of using people against their will, but I'd suffer a bit if I thought I was making anyone unhappy."

Elliott Erwitt

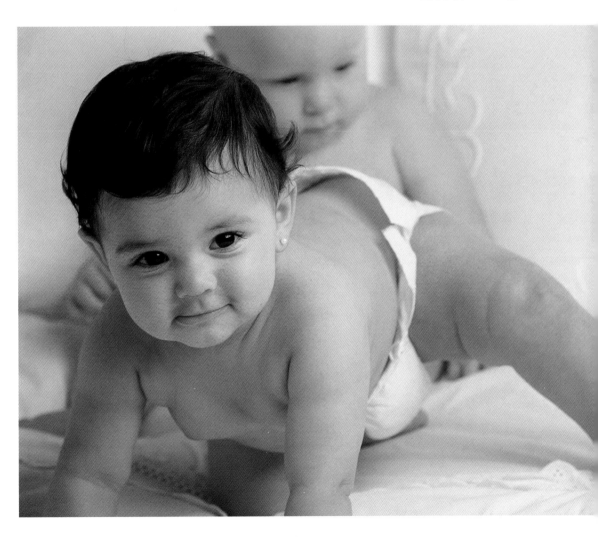

technical details
35mm SLR camera with a
35–70mm zoom lens,
an 81A warm-up filter and
Kodak Ektachrome 64.

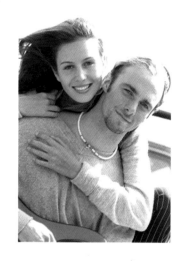

Technique

You're the photographer, but be prepared to lose a little control when photographing teenagers, for the sake of introducing informality and a more relaxed atmosphere. Keep lighting simple so that your subjects have the freedom to move around, and don't put time constraints on the session since this will only introduce tension into the proceedings. Work out what you want to achieve in advance, discuss this with your subjects before you start, and then listen to any ideas they may have as well, so that you're working together. A zoom is a good lens to use for portraits of this kind, because this will allow you to change your viewpoint quickly and easily without disturbing the flow of the session.

Composition

If your subjects are relaxed, make sure that your approach is as well. A slight tilt of the camera here is against all the rules, but adds to the dynamic nature of the composition, while the fact that the couple are both looking away from the camera position is likewise usually considered taboo but again it has allowed the picture to have a feel that's all its own. The photographer has taken advantage of the natural elements that were found at this location, in particular waiting for a moment when the wind blew the girl's hair out behind her, adding a relaxed and informal touch to the portrait.

Lighting

The subjects are backlit here, so that the faces are largely in shadow and modelling is subtle. Left as it was, however, the contrast levels in this picture would have been too high, and the facial features of the subject would have been too dark and so a touch of fill-in flash was required to even things out. A reflector, too, would have performed the task: for an extra touch the photographer could have chosen to use one that was made of gold foil, so that the light it threw back would have added warmth to the subjects' faces.

Getting the right kind of relaxed feel into your portraits is the key to success, particularly when dealing with teenage subjects. Don't dictate from behind the camera: allow your subjects to find their level and to contribute to the relaxed composition.

Technique

The tightly framed image to the right was taken in the style of a candid picture. Shot with a zoom lens set to a telephoto position to enable the photographer to crop in tightly on his subjects without intruding on their space, this romantic image has a very contemporary and relaxed feel to it. The zoom is perfect for an image of this type, allowing the photographer great freedom to alter the tightness of the framing quickly and without moving position.

Composition

This is a classic picture of a modern couple. The photographer has been less concerned to produce a likeness of his subjects than to capture the atmosphere of the moment, and consequently this is more a portrait of love than of the subjects involved. Like an artist producing a sketch, all the photographer has needed to do to create this image has been to record very few key details. We don't need the man's face in sharp focus, for example, nor do we need to see his complete hand to realise that he's caressing the girl's face. The picture is primarily about mood and intimacy, and the informal nature of the composition has achieved this beautifully.

Lighting

The photographer has used available lighting for this black-and-white scene, preferring its subtleties to anything that could have been produced from an artificial source. By choosing to shoot under moderately bright overcast conditions, it's been possible to work with a light that's not too contrasty but which has been strong enough to allow a reasonably fast shutter speed, around 1/125sec, to be set. Had it been necessary to introduce any more light into the scene, this too could have been done naturally through the use of a reflector positioned just under the faces.

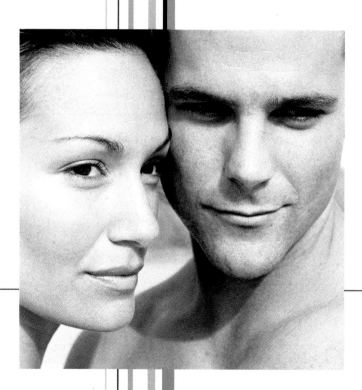

The closeness of the faces and framing has created a feeling of intimacy, and the lack of eye contact makes the couple appear unaware of the camera's presence.

This contemporary portrait relies on just a few key details to place the image of a couple in love in the mind of the viewer.

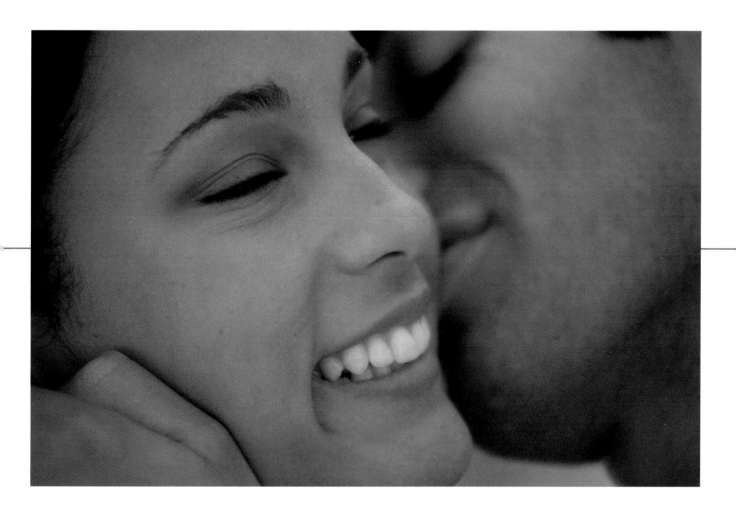

technical details
70–210mm zoom lens at the 100mm setting. Film used was ISO 100 colour print film.

Technique
A telephoto lens tends to flatten perspective and facial features. It suits this subject, where the lighting is unable to effectively show form and depth in the facial features.

Lighting
The strong sunlight has been controlled using a reflector, which bounces it back into their faces. The brightness of this reflected light can be adjusted by positioning the reflector closer to or further away from the faces.

Composition
The gentle tilt of the girl's head towards her companion has introduced a sense of life and movement into the picture. If heads are on the same level, and both subjects are looking rigidly into the camera, then the resulting portrait will be painfully formal, an approach which is entirely unsuitable for a picture of young children.

Try shooting additional shots, especially if the lighting or set-up is unusual or unrepeatable. They provide useful back-ups, and clients will often welcome such extras.

Cropping
If a photo session is working well, take plenty of film, and make sure that you take a few individual portraits as well. These are very simple pictures, tightly cropped to emphasise the subject, and taken with a medium telephoto lens, so that what background can be seen is reduced to soft focus and can't distract.

technical details
35–70mm zoom lens at the 70mm setting on a 35mm SLR. Film used was Fujichrome 100.

Effective aperture technique can allow close control of depth of field, allowing the juxtaposition of sharp and blurred areas within a scene to give effective results.

Technique

Shallow depth of field has meant that the foreground and background details have been thrown out of focus, while the couple who are the central point of interest have been rendered sharp. A 35–70mm zoom was used at its longest setting to produce this image: the characteristic foreshortening effect of a telephoto lens was ideal for this situation, because it made the foreground and the background appear apparently closer to the subjects than they were. The telephoto lens also features a very narrow depth of field, which can be used to full effect by selecting the maximum aperture. Use of an SLR will let the photographer know exactly where focus is falling: if anything other than maximum aperture is selected it's still possible to see how the final picture will look by using the stop down facility on the lens, provided that it features one.

Composition

This is an unconventional approach to portraiture, but one that is visually very strong. Combining a foreground that is out of focus with a background that is the same has effectively surrounded this couple with a rough and unstructured frame. No detail is apparent, and so there's an element of mystery created too, which gives this picture an extra lift. Traditional eyes would doubtless see this compositional arrangement as messy, but in contemporary portraiture a visual trick such as this, provided it's been well executed, helps to set work apart from the crowd.

Lighting

Late afternoon lighting produces a soft quality of light that is perfect for such moody portraits. The photographer has also used a low-strength fog filter to add to the effect.

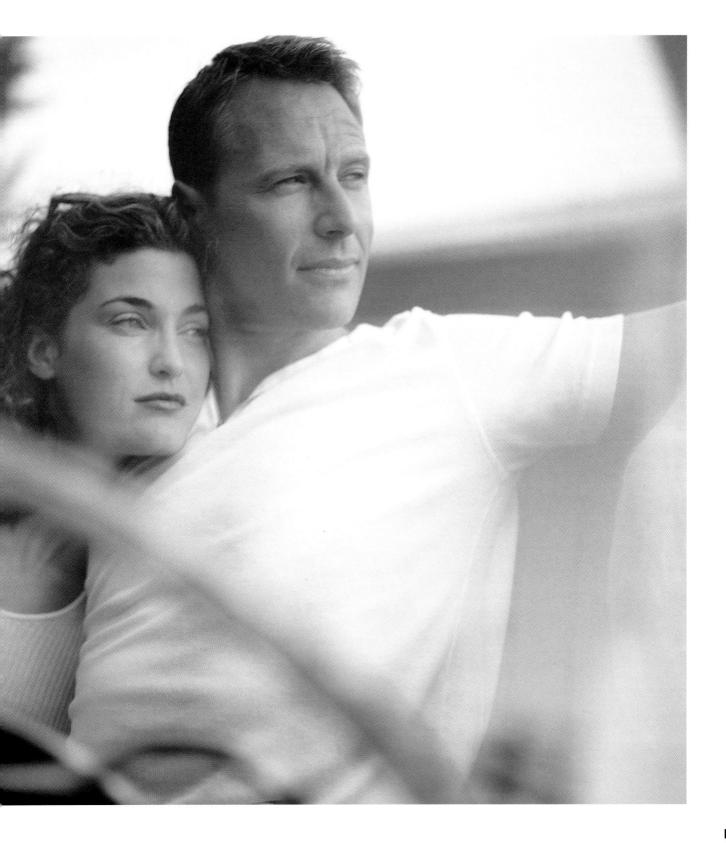

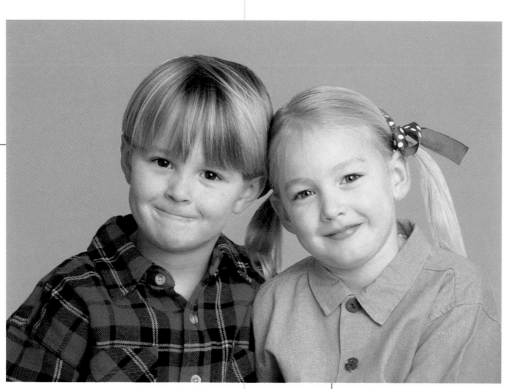

Technique

This formal portrait is the type of image preferred by most parents and relatives. When the exposure and position have been verified by using instant film the photographer is then free to experiment with different poses.

Colour

The boy's checked shirt creates a strong colour accent, but it suits his personality. It doesn't dominate the image because it is balanced by the colour of the girl's blouse.

Composition

A change of background and a change of pose adds some visual variety and interest. Notice how the boy's and the girl's expressions convey a moment of fun that has been reacted to and successfully captured by the photographer.

A change of pose. Hands can be a strong visual distraction when used in a photograph. It's best for them to hold a prop or to be incorporated into the composition in a non-intrusive way.

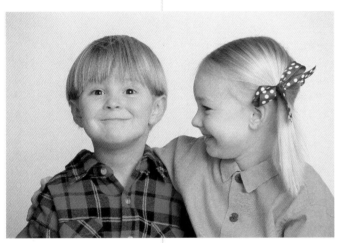

Siblings or twins who are comfortable in each other's company make great subjects. Their reactions to the camera and to each other can produce delightful portraits.

Black-and-white images can look really effective in moderate lighting with the contrast levels greatly reduced. There's a softness which is perfect for the subjects, showing the warmth and intimacy of a mother-child relationship.

Composition

One image, where the subject is obviously aware of the camera's presence, is intimate and revealing, while the other has a more candid feel, and could almost have been taken unobserved. Eye contact, or the lack of it, determines almost more than anything else what kind of overall mood a picture will have, so ensure that you're aware of the fact and pose your subjects according to the look you want to achieve.

Colour

Black and white is back in vogue with a vengeance, and being used by more and more photographers to bring a sophisticated and timeless feel to their pictures. It's versatile, can be processed and printed in a home darkroom to give a huge degree of control, and prints can be toned a variety of colours to add extra effect, and to increase longevity.

Framing

Tight framing holds a picture together, and it's rarely necessary to show a complete subject in order to put across the visual point that you're trying to make. Both of these pictures demonstrate this point well: the boy, for example, has a fraction cut from the top of his head, but instead of looking like a piece of clumsy composition the portrait has instead been made stronger, and the boy's relationship with his father has been emphasised. The mother and child portrait features an even tighter crop, which has made the face of the mother, and her eyes in particular, the central point of the picture. Using black and white gives the photographer the opportunity to produce prints in a home darkroom, and this is the stage when framing can be adjusted to suit. Even those pictures that have been composed with great care can often benefit from a small trim, since even an SLR will struggle to give the complete scene that will be recorded in the viewfinder.

Flash

Fill-in flash can often be a more convenient alternative to a reflector, especially for solo photographers. A flashgun with variable output and set to minimum power was used here.

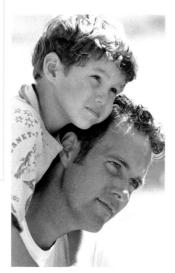

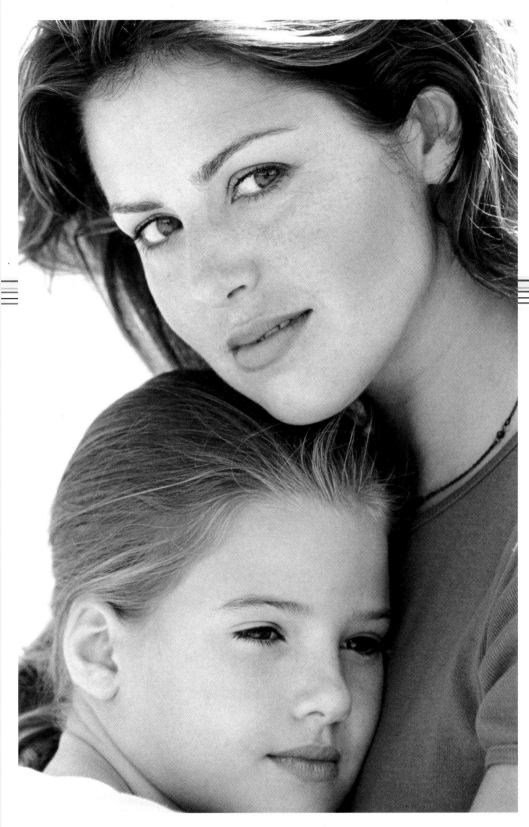

Reflectors

A reflector is an option in a situation where bright lighting is likely to cause shadows on the subject's face. The reflector bounces light from the light source – outdoors this would be the sun – back into the subject's face to reduce the shadows. Reflectors can be home-made, such as a piece of white card or plastic, or they can be professionally made with different surfaces and able to be folded down for portability. In strong lighting conditions and in the absence of flash, a reflector can be a portrait photographer's best friend.

Fill-flash
Fill-flash is a controlled amount of flash illumination that adds light to areas of shadow. An ordinary on-camera flashgun with a variable power output can be used for fill-flash. Rarely is the full power output used or necessary. A fraction of the flashgun's power is used to fill the shadows, while the camera's exposure system takes care of the rest of the lighting. Some cameras with built-in flash have a special fill-flash mode that automatically works out and balances the flash output with the existing exposure reading.

Lighting
This is a clear example of a photographer using strong sunlight to advantage. The light is coming from above and to the subjects' right (look at the angles and positions of the shadows).

Composition
A low camera angle, meanwhile, has ensured that the water itself acts as foreground and background, while the same-level eye contact that's been established gives the viewer the feeling of being involved in the scene.

Colour
The surrounding colours are bland and non-intrusive. Even the colours of the goggles don't take away the emphasis on the subjects' faces.

Props
Water is a great natural prop, and can suggest all kinds of poses and activities that can be used to great effect by the photographer. The picture here is obviously contrived in the combed-back hair of the models and the carefully arranged pose, yet the image still has great appeal because the setting has made it look believable.

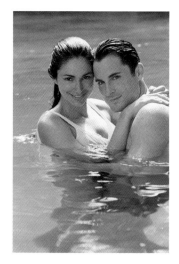

Here the photographer has compensated for the effects of strong back-lighting by using fill-in flash. The couple have had their wet hair swept back to reveal their faces, and are standing in shallow water with their feet resting on the bottom of the pool for stability.

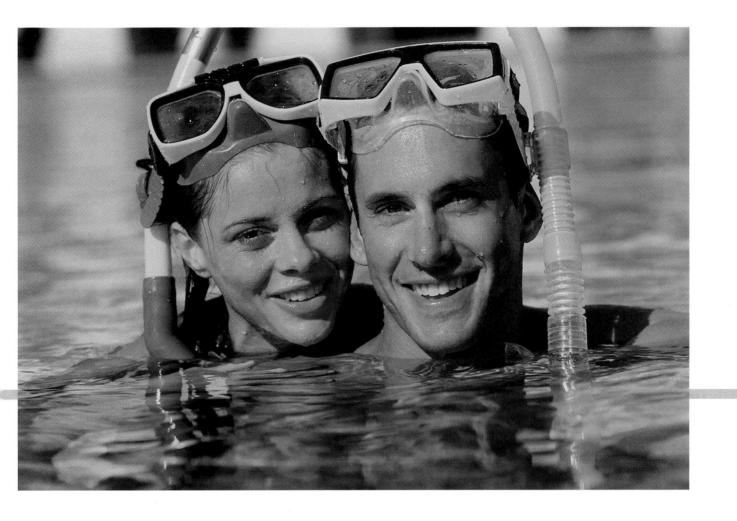

Seniors offer the photographer a rich source of striking portraits. Their faces are strong and etched with character that can be sensitively brought out through the right choice of lighting

Technique

The key to producing a believable portrait is not to over-elaborate. The props used here were simple and believable, and the picture was easy to set up and arrange. Try to tell a story within your photograph: if the viewer has enough visual clues, it will be an enjoyable experience for them piecing together the build up to this moment. A long lens has been used here to pull the background up behind this couple and to help place them in the environment, while depth of field has been controlled carefully to ensure that it's soft and doesn't distract you.

Composition

The picnic basket provides a strong visual balance on the right-hand side of the picture, while the heads of the couple are at different levels to break up the symmetry. To ensure a natural look in pictures such as this that have been set up, ask your subjects to talk and relax, and to interact with each other. Then take your pictures almost in a candid style as the scene unfolds: don't ask them to freeze at any given moment, rather keep shooting and directing, and ask for something to be carried out again if you feel you didn't catch what you required on film.

Lighting

Lighting is bright and, thanks to the trees around this location, is dappled and broken up, which all adds to the interest of the picture. By ensuring that the couple was located in an area of shade, however, the photographer has used light that has flattered them, while the brightness of the scene was still enough to ensure that their faces didn't require further illumination from a flashgun or a reflector.

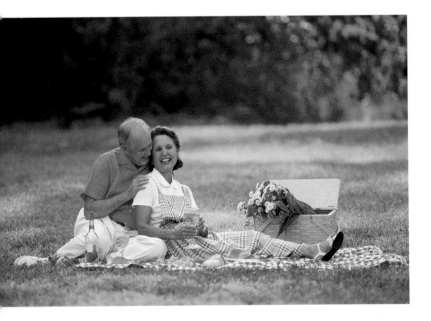

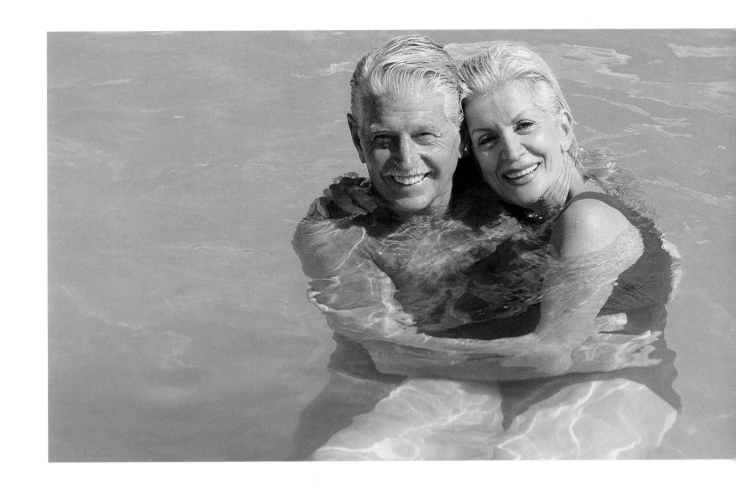

If you want to achieve natural-looking results, you need to set up natural-looking situations. Make use of the many settings that you can find around you, and don't introduce inappropriate or distracting props.

Lighting

Some illumination came from a small window to the subject's right. The door of this potting shed was left open to allow additional light to supplement the illumination from the window.

Technique

This was a low-viewpoint shot, taken with a standard 50mm lens on a 35mm SLR. The photographer used the full image frame. None of the elements were superfluous, all of them being intended for inclusion.

Composition

The subject has adopted a relaxed stance as he poses in his work place. The clothing and the items help to put the subject into context and provide a visual balance between him and his surroundings.

Correct Exposure

The spontaneity of portrait subjects – their facial expressions or physical gestures – is often difficult to repeat and is best captured first time. So it's wise to ensure that exposure settings are also right first time. In the studio the photographer's allies in gauging a correct exposure are a flash meter and, for back-up, instant film. Outdoors, the photographer can rely on a separate or an in-camera spot-meter, a tried and tested in-camera exposure system or at the least a grey card. This card is used to give an average exposure reading in existing outdoor lighting. The photographer simply points the camera at it in the available light and makes a note of the resulting exposure setting, using this as the basis for resulting exposures.

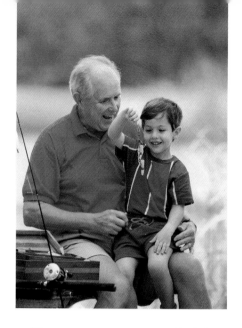

Colour

The colour of clothing plays a subtle role in any type of portraiture. Here the red in the shirts complement each other. Red also symbolises vibrancy and life.

Composition

Some seniors' recreational hobbies, such as gardening, fishing or sports, take place in outdoor locations. This gives the photographer more options in terms of composition and colour compared to the studio.

Technique

Judicious use of simple props gave these subjects something to base their pose around, and it helped to make the scene appear more natural. It also helped their interaction and, by acting out a simple moment, the expressions and actions had an authentic feel to them.

Young children and seniors invariably interact brilliantly. All a photographer may need to do is to set up a simple situation and to add some props, and then simply step back and wait for the scene to develop.

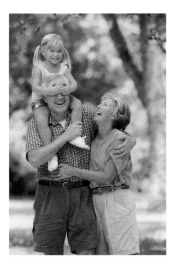

This is a typical snapshot of
grandparents and grandchild. Yet it is
beautifully composed, with the three
figures forming a balanced shape.
Note also how the arms connect and
link all three.

Lighting

Bright daylight can be the outdoor photographer's friend as well as an enemy. Tricks such as making sure the figures aren't directly facing the sun, placing concealed reflectors opposite the subjects, and controlled use of fill-in flash are the photographer's main allies.

Technique

When photographing people relaxing, give them the opportunity to dictate the pace of the session and to offer you ideas for pictures. If they feel that you're interested in what they're doing, they're likely to give more, and will feel that you're on their side. When photographing a couple, as here, encourage some banter between them so that the camaraderie shows through, and smiles that result will be natural and unforced. When a situation like this develops, you'll need to act quickly, because a natural pose that you then ask to be held will quickly lose its spontaneity.

Composition

Although it looks like a casual photograph it required some planning. Just enough of the boat and the surroundings have placed the subjects in context. And fill-in flash was used to modify the strong side-lighting. A wide-angle telephoto zoom was ideal in this situation, where the photographer needed to lose distracting background details.

Those who are being photographed appear more natural if you capture them engaged in an activity. It guarantees that expressions will be livelier and that they will feel less inhibited by the presence of a camera.

Colour

The strong, simple colours, emphasised by the bright lighting and precise framing, help to make this shot a success. A long telephoto lens has isolated the two running figures from the unfocused background.

Shutter speed

When subjects are moving, you'll need to set a shutter speed fast enough to freeze the action, unless you're intending to introduce some deliberate subject blur for effect. This couple was heading towards the camera, and so required a shutter speed less than that which would have been required for a couple moving across the frame, where the apparent speed would have been greater. Be careful, however, because sometimes arms will be moving at speed too, and a shutter speed that's too low will freeze body movement while leaving arms blurred.

Composition
Because of the slow pace the photographer has ample time to get into position. The distances required in golf demand the use of a telephoto or zoom lens.

Technique
Some outdoor activities are less strenuous than others. Golf has an easy-going pace, giving the photographer enough time to prepare and anticipate poses. And in this situation the photographic equipment requirements are modest.

Lighting
Bright, overcast lighting suits subjects where sharply defined details are not of prime importance. The lighting is even and the shadows are not too strong.

Families are a testing, but rewarding, subject for photographers. Look for ways of showing family relationships, and direct the shoots to get the best results

Pleasing and natural groups are often formed spontaneously when a camera appears, but take time to direct and to ensure that there are no obvious compositional flaws.

Composition

This flowing picture runs naturally and in an attractive manner from the boy's body along the mother's arm and then across the three faces in the top of the picture. To avoid the problem of all the subjects gazing into the camera, the photographer then directed the mother to turn her head and look at her child, a simple movement that gave the picture a much better and more natural feel. Finally a low vantage point level with the eyes of the boy was taken up, and this immediately makes the family group assume greater dominance in the frame.

Colour

The beach ball's colour and pattern could have been a distraction, but its position at the base of the tableau and within the group has incorporated it into the image.

Technique

A zoom lens with a telephoto setting is an ideal framing tool. The photographer can choose a range of framing options, so changing the emphasis of the subjects and their surroundings.

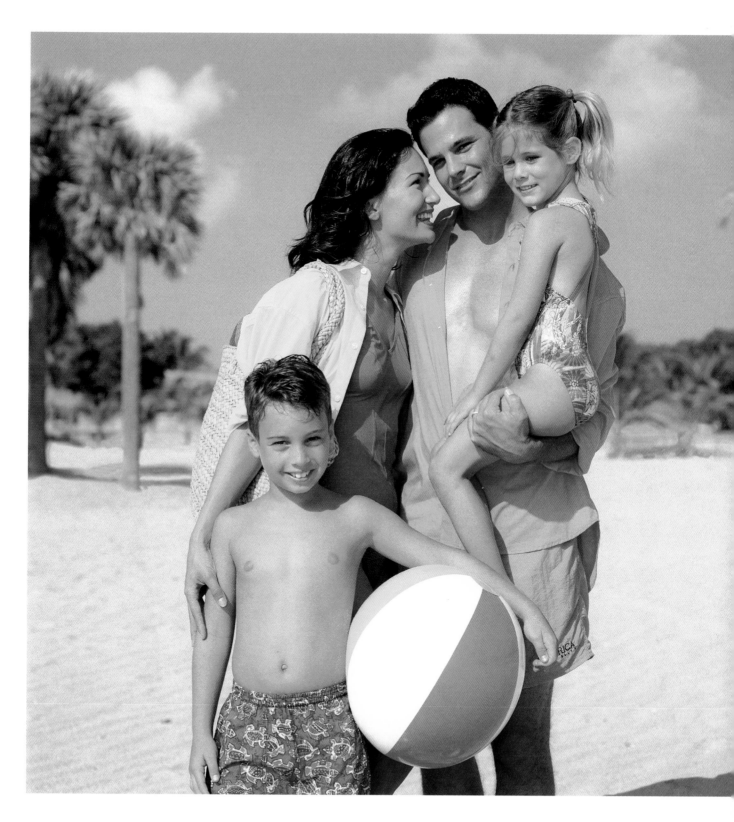

The simple snapshot has brought joy and fond memories to millions because of the subject matter rather than the image's creative significance.

Panning

Moving the camera in the same direction as an action subject is a popular trick of the sports photographer. It allows a slow to medium shutter speed to be used so as to achieve the streak effect behind the subject. The technique is to press the shutter button just before the subject fills the frame, slowly swing the camera across the frame, then release the shutter button at the end of the swing.

Technique

Overexposure has created a semi bleached-out effect, with contrast being reduced. It's excellent for creating a mood for people portraits, with the resulting image appearing pale and with low contrast.

Lighting

Early morning or a foggy background is ideal for a high-key portrait such as this, with virtually no shadows. No flash or reflectors were needed.

Colour

The lighting softens colours, and the neutral hues of the clothing add to the effect. With this technique even more vibrant colours will lose some of their intensity.

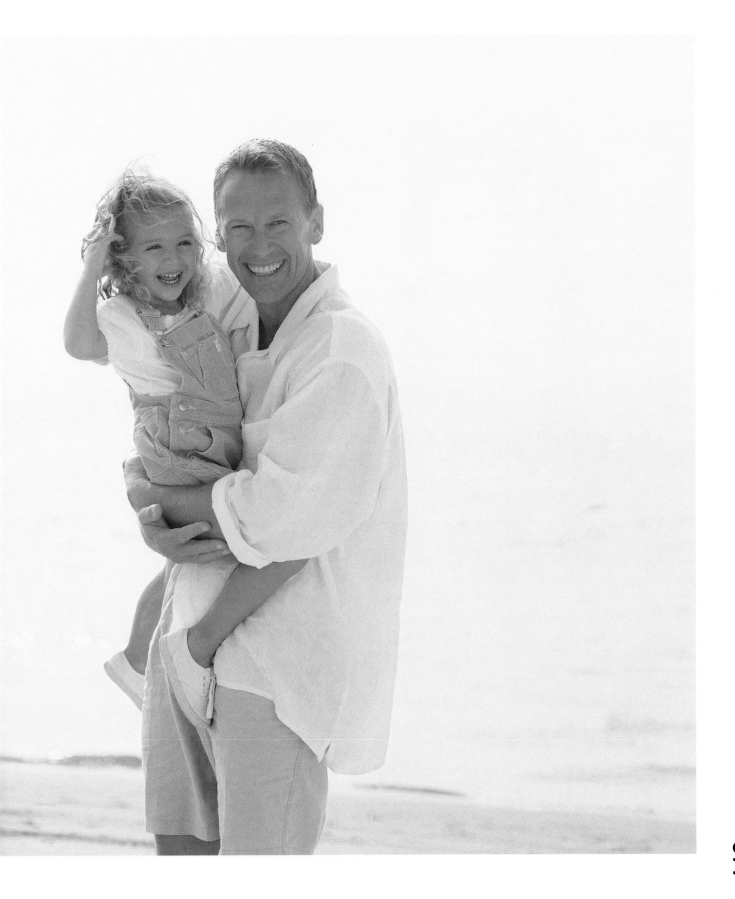

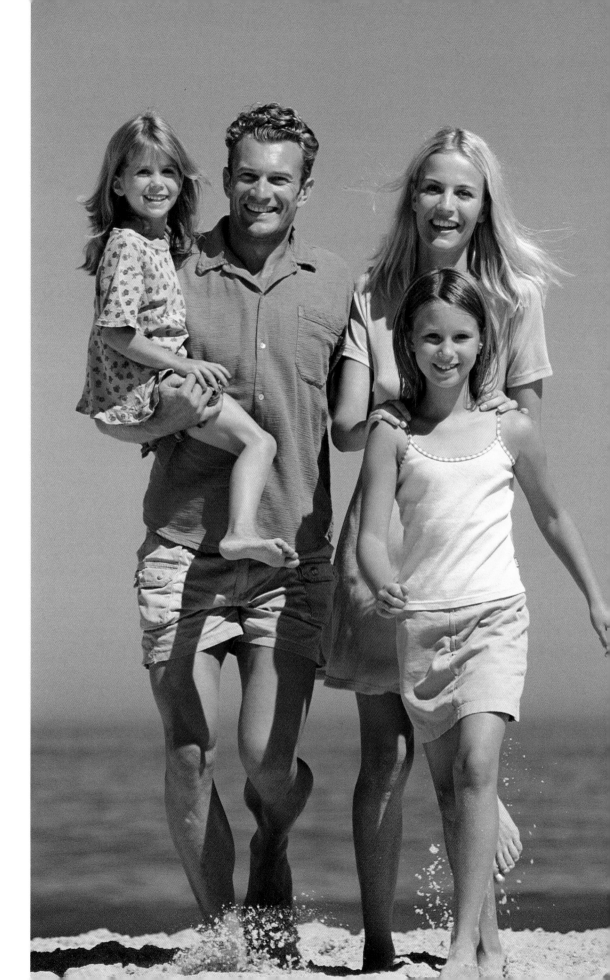

Technique

This picture, right, required a carefully judged exposure. Even a half stop of extra exposure would have started to dilute the colours, while the light was strong enough to ensure that underexposure would have darkened the shadows to an unacceptable degree. The solution is to use the meter techniques previously described, but also to take the extra precaution of bracketing perhaps a stop either side to ensure that the optimum result will be achieved.

Composition

A dramatic twist to the camera has added a very simple extra touch that has made this picture much more dramatic. The horizon tilts at an alarming angle but, because it's so obviously been achieved intentionally, the picture still succeeds.

Lighting

Lighting rules are sometimes meant to be broken. Harsh, direct overhead sunshine has produced hard shadows beneath the subjects' facial features. Yet the shadows also serve to emphasise shape and form.

Sometimes all you need to do to introduce a greater degree of animation into a scene is to stand back and ask your subjects to walk into your frame. The sheer act of moving means that everyone is immediately more relaxed and natural, while a further request to kick up a little sand has added a telling touch to the base of the picture.

The three shoulders leaning into this tightly framed composition are balanced by the woman's left arm. Strong top-lighting has produced the same effect as a studio hair-light.

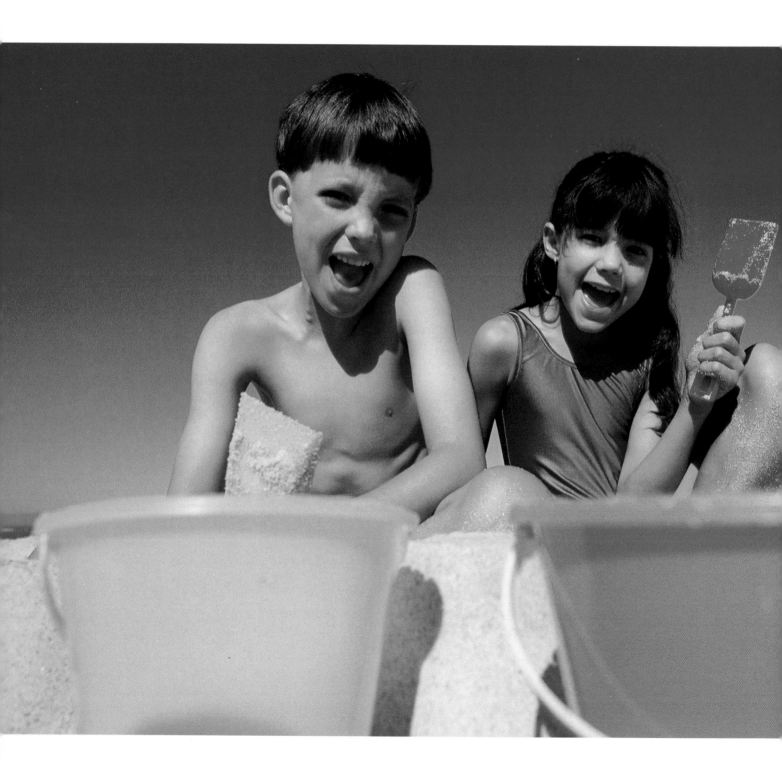

These two plastic buckets immediately set the scene in this beach shot. They provide an activity for the two children, and their colours are perfect for the lighting and the location.

Technique
The photographer was prepared to exploit the brightness and harshness of the lighting. No fill-flash or reflectors were used, and this helps to retain the snapshot feel of the image.

Composition
The buckets are balanced by the two children whose position and lively expressions seem part of the whole effect. The photographer's low viewpoint has made the subjects appear more dynamic.

Colours
The bright colours of the buckets and spades complement each other, while the blue sky above is the perfect backdrop. A polarising filter has been used to make the colours in the subjects and the sky appear more intense.

Filter

A polarising filter has been used to increase the colour saturation of this scene. The amount of extra saturation achieved depends on the angle of the reflected light and the orientation of the filter, which features two rings that can be turned in relation to one another. This filter also performs the useful role of darkening the blue of a sky, which has helped to increase the contrast of these subjects against their background here. An SLR will allow you visually to check the effect that the filter is having, and you'll be able to adjust the two rings until the effect that you require is visible in the viewfinder of the sky.

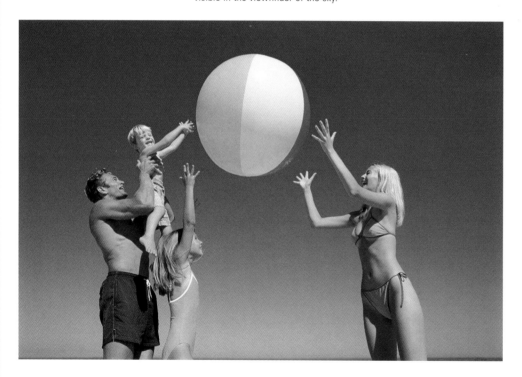

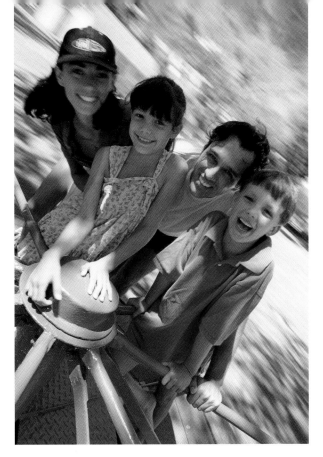

Technique

This picture makes use of an element within a scene that was moving, while a medium shutter speed, no more than 1/125sec, has allowed the family to remain sharp. Simplicity itself to take, the photographer took up a position in the centre of the ride, and then focused on his subjects while the background behind them was reduced to a blur by the speed of movement. A wide-angle lens has included the subjects plus just enough of the merry-go-round and the background to place them in context. The frame-filling subjects benefit from the vertical format. The arrangement and pose of a portrait subject sometimes suggest what image format will be best.

Lighting

The bright shade has supplied sufficient illumination for the photographer to use a fast shutter speed, freezing the subjects on this moving merry-go-round. In the second image we can see some of the sunlight on the child's hands, but this is a visual distraction.

Composition

The excitement and movement captured in this picture is enhanced by the decision of the photographer to turn the camera at a sharp angle. The composition still looks natural, however, because of the framing of the subjects within the picture, particularly the position of the girl in the top left, who, although leaning at an angle at the time the picture was taken, now appears upright.

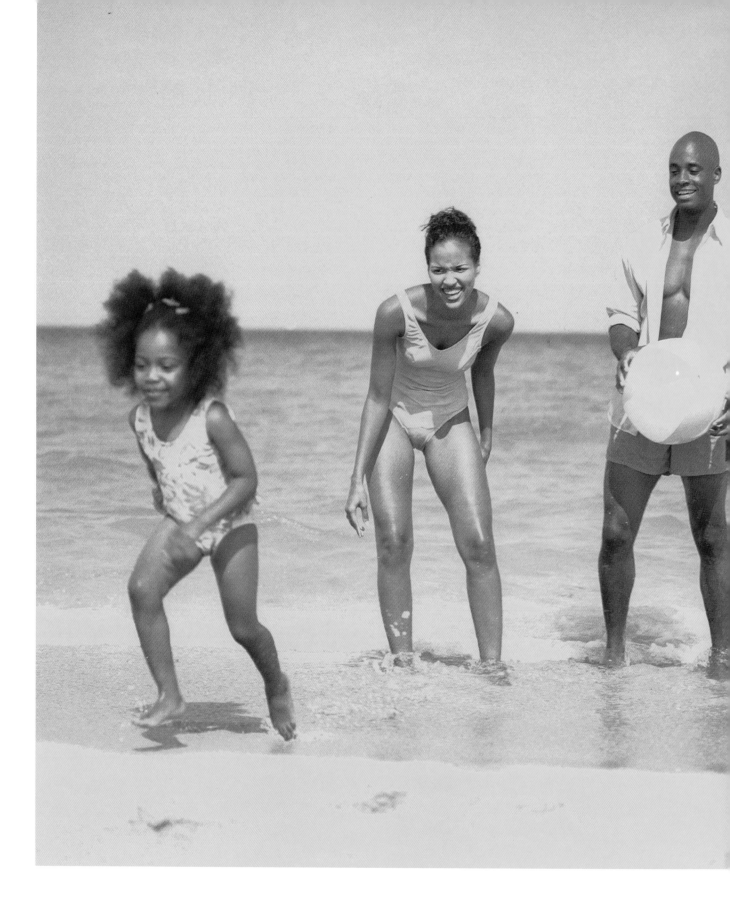

Photographers of the family need to be prepared for unplanned off-beat moments. These are often the source of great and enduring images.

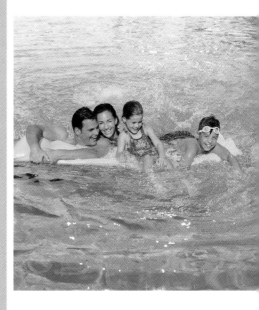

Posing

By encouraging subjects to be involved in an activity, you give yourself a much greater chance of achieving a picture that's natural and informal. You can encourage the posing you're after by directing the scene, and to be successful you must develop a good eye for detail. Look for awkward shapes within the picture – hands or legs that are clumsy and badly arranged or an imbalance within the figures.

Sometimes a brilliant picture is ruined by tiny things: try to make sure that you pick them up at the time you're shooting.

Composition

A good snapshot can demand many of the skills of the pre-planned portrait. The photographer needed to ensure that all four subjects' heads were not in the water and were turned towards the camera position. The subjects have been centred in the frame, and the water itself acts as a frame for them.

Lighting

In bright conditions like these and with such active subjects no modification of the lighting was needed. In many ways the situation is better suited to a snapshot camera than a studio-type camera.

Colour

As well as the technical considerations the family portrait photographer must also be aware of the potential commercial uses of such an image. The photographer has left space above and below the subjects for text or a logo to be positioned.

The mood is lively and exuberant. This makes up for the lighting which is bright but a little too strong.

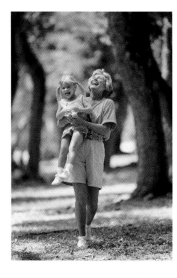

Composition

This picture shows what can be achieved with even very simple composition. Using a medium telephoto lens, the photographer has brought up the background behind his subjects while shallow depth of field has rendered it soft and less distracting. The greater distance the long lens allowed between camera and subject has created a more informal feel. With everything in place, it was then a case of allowing the situation to develop, and the couple was encouraged to interact with each other and to develop their own ideas. This was the only way to capture a smile and a pose this natural: had the photographer planned this picture more specifically, it's unlikely it would have been anything like as successful.

Technique

The mood is happy and relaxed. A moderate telephoto lens was used to frame the subjects. The exposure setting was taken from their faces. If an average reading (including the white cardigan) had been taken it would have resulted in the wrong exposure.

Lighting

The time of day is almost early evening and the lighting is soft and diffused. No reflectors or fill-in flash were used.

Colour

Black-and-white film adds just the right mood to the image. It reduces even the strongest colours to a range of tones. The image's impact then has to rely on the subject matter and tonal range.

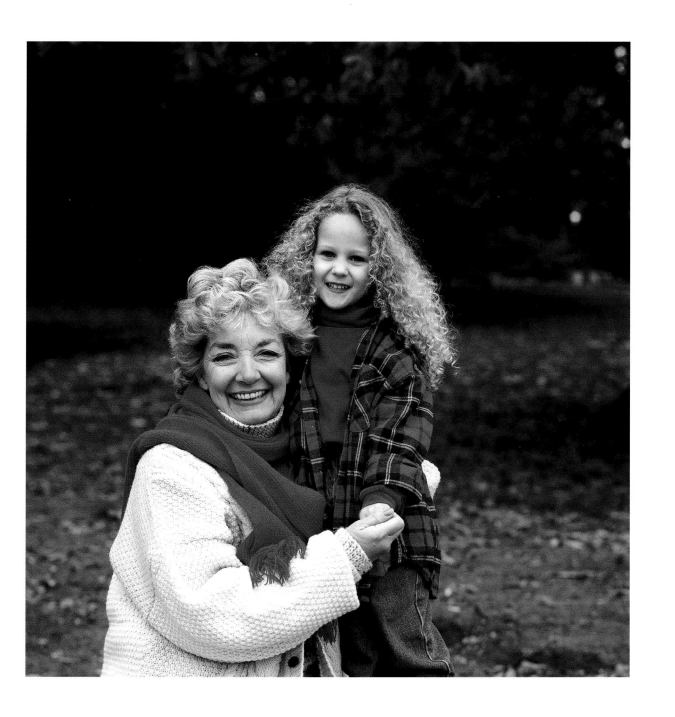

A relaxing family group in a classic snapshot situation. The side-lighting is sufficient to light all three faces evenly.

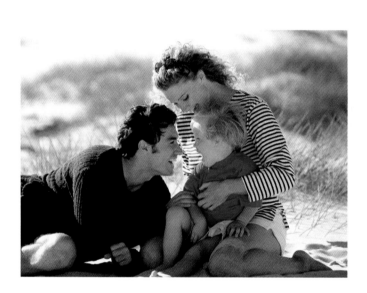

Composition

A lively family group and a simple pose, but one that's been highly effective. First the father sat down on a bench, then his wife on his lap and finally their child on the mother's lap. The photographer asked his subjects to put their arms around each other, so that the hands all met around the front of the child, which made an attractive arrangement. Then the camera was simply moved one quarter of a turn to the right, so that the three subjects appeared to be standing: the trees in the background give the game away, but the initial impression created by the picture is still remarkably strong.

Colour

Once again the use of monochrome has added impact to the picture, and the effect is completed by the use of tone. By cutting out the distraction of colour, black and white allows the elements within a picture to work harder.

Lighting

Diffused, overcast daylight provided the soft, even lighting conditions. In this situation the photographer just needs to set a preferred exposure setting or put the camera on auto-exposure to capture the moment.

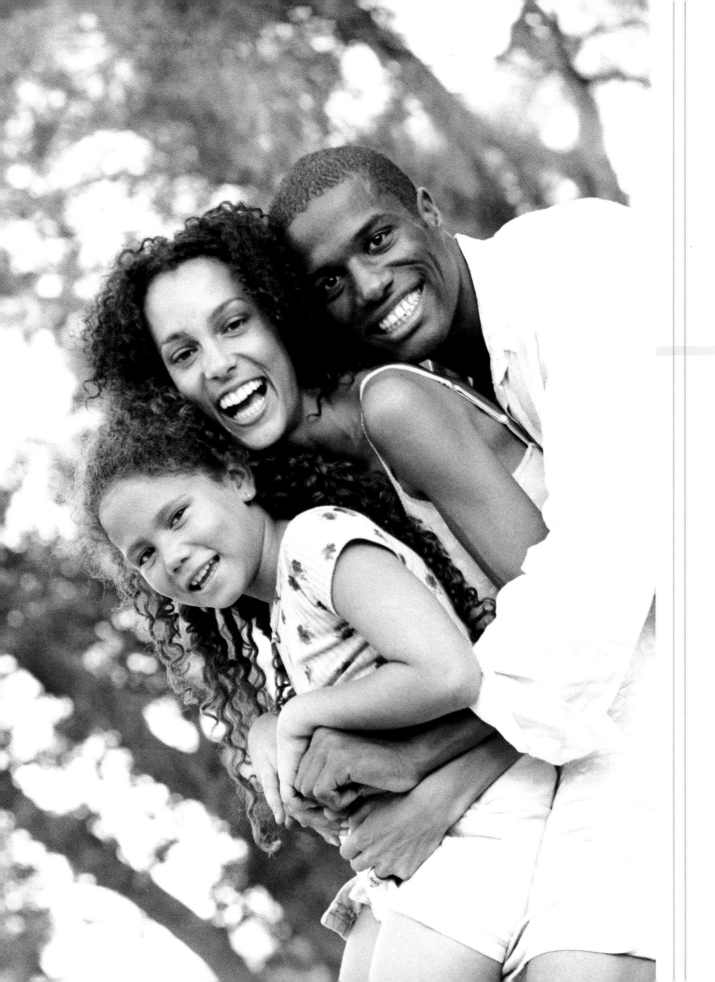

Studio portraits needn't be formal affairs. With a pre-selected lighting set-up and posing position the photographer simply needs to arrange his subjects, or allow them to arrange themselves.

Composition
Several arrangements were tried but this one was selected because the subjects' faces were close together and the composition formed a pleasing balance.

Lighting
A softbox was placed at the camera's left and in a raised position. No reflectors were used, and there was no illumination on the background.

The family is a popular and obvious subject for a group portrait. An informal and active family group demands anticipation and good snapshot skills from the photographer.

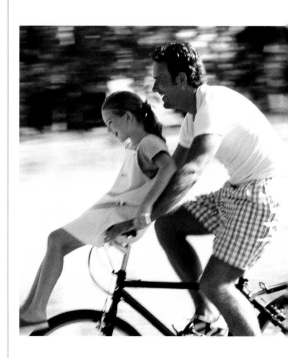

Lighting

It's a free and easy type of subject but the photographer has not forgotten to make sure that no strong lighting is falling on to the subjects' faces.

Colour

A colour and a black-and-white portrait, taken at the same time and at the same location. The colour image depends on a range of colours, while the black-and-white one relies on its range of tones; its shades of grey. Both images look different yet, by covering one and then the other, you can see that both have individual impact.

Composition

The horizontal frame is adequately filled with the father, the children and the bike. A medium shutter speed was used. The camera was panned so as to keep the subjects in the frame while the photograph was being taken. It's a technique used by sports and action photographers.

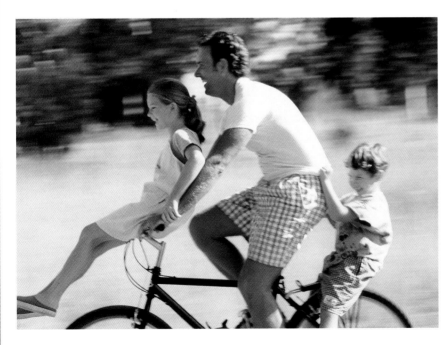

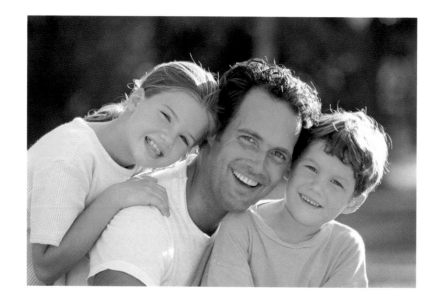

The family portrait photographer needs to bring a fresh eye to what may seem a limited choice of compositions. Here are two variations on ways to pose a three-member family group.

Composition
It pays to experiment with poses in order to give a fresh look to what might otherwise be repetitive arrangements of subjects.

Technique
Such images can just as easily be taken with a compact camera as with an SLR, though aspects of technique such as using fill-in flash, making sure the subjects were not facing into the sun, creating the leaning pose and putting the subjects at their ease are skills of the more experienced photographer.

Colour
Colour is often an aspect taken for granted but it can make the difference between a balanced or an unbalanced composition, no matter how well the other elements have been arranged. The colours here do not clash with each other or take attention away from the subjects' faces.

Shooting against the light, or *contre-jour*, is a time-honoured photographic technique that produces vibrantly li portraits. A reflector or flash is usually required to balance the sun's illumination.

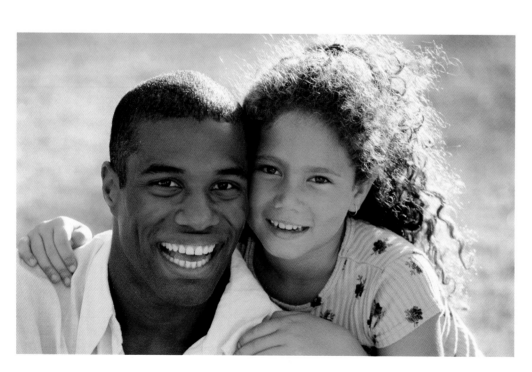

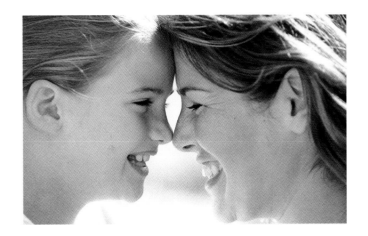

Technique
A high-key effect can rely on existing lighting conditions or it can be created by deliberate overexposure. The greater the degree of overexposure the lighter the result.

Lighting
Slight overexposure plus a reflector have created a high-key effect.

Composition
A large aperture has made background detail insignificant, concentrating the viewer's attention on the two subjects. The pose is an affectionate and relaxed portrait of mother and daughter.

glossary

Back-lighting – Natural or artificial illumination that is in the background or directly behind a subject. Unwanted back-lighting can be compensated for by an adjustment in exposure. Back-lighting can be used to deliberately create a halo- or glow-effect behind a subject.

Background paper – A fixed sheet of paper that is large enough to provide a background to a portrait. Can be fixed or part of a large roll.

Ball and socket head – A moveable joint on top of a tripod that provides an infinite number of adjustable positions for an attached camera.

Barn doors – Moveable flaps situated near the front of a studio light that can be adjusted to control light direction.

Bounce flash – A technique that 'bounces' flash illumination off a reflector on a flash unit, or a nearby surface such as a wall or ceiling, on to the subject. The effect is to spread and soften the light.

Brolly diffuser – A special brolly or umbrella covered with semi-transparent material and attached directly to the flash unit. The flash is fired through the brolly to create a soft or diffused lighting effect.

Dedicated flashgun – A flashgun that is totally compatible with, or dedicated to, the exposure metering system of a specific camera.

Depth of field preview – A control that shows the amount of the area in front of and behind a subject that is in focus, depending on the aperture that's been selected.

Diffuser – A device that softens or diffuses illumination or creates a diffused effect. A diffuser can be semi-transparent material covering a light source or a filter that is placed over a camera lens to produce a diffused effect.

Digital read out – Information shown in digital form in an LCD or LED panel, such as on a camera, light or flash meter or on a flash unit.

Exposure Value (EV) – A particular exposure setting using any chosen aperture and shutter speed combination that will produce a correctly exposed result, depending on the existing lighting conditions. An EV range provides several aperture and shutter speed options to choose from. Camera exposure systems and external light and flash meters have specific EV ranges.

Fill-flash – A blast of flash that provides just enough illumination to light or fill any areas of shadow.

Flag or French flag – A variation on the barn doors. It's a single flap of opaque material attached on to or near a studio flash so as to partially or completely block illumination.

Flash meter – A special type of light meter that's used to measure flash illumination. The appropriate exposure required for a given amount of flash illumination is shown on a digital read out.

Flash sync lead – A cable that connects a camera to an external flash unit, so that when the shutter button is pressed the external flash unit is automatically triggered.

Flat – A free-standing card or similar material that is used as a reflector. A flat can be large and used as a background or smaller and positioned behind, above, below or to either side of the subject.

Gel or Acetate – A piece of special coloured plastic that can be used like a filter, placed over a camera lens or over a lamp or studio flash.

Glossy surface – A shiny surface that may also be highly reflective, such as chrome or shiny plastic.

Guide Number – The Guide Number or GN of a flashgun is an indicator of its maximum power output. The higher the GN the more powerful the flashgun. If you use a flashgun which has a GN of 25 and if your chosen aperture is, say, f/5.6, there will be sufficient illumination to light a subject that is 4m away. Flashguns built into cameras usually have a GN of around 12, while externally attachable flashguns usually start from 25 and go as high as 90. (GN figures for flashguns are based on ISO 100.)

Halo effect – See Back-lighting.

Honeycomb – A grid designed to look like a honeycomb pattern and placed over a light source to provide more controlled, directional lighting.

Key light – The main, usually the most powerful, light source.

Lighting stand – A free-standing support for a studio flash unit.

Matt surface – A non-shiny surface, such as felt or stone, that has little or no reflections on it.

Modelling light – A special type of light that is used as a guide for the eventual lighting effect.

Multi-sync adaptors – These are special adaptors containing more than one flash sync socket for firing more than one external flash unit simultaneously.

Needle-and-dial read out – A system used to display the read out from a light meter, usually found in older light meters.

Ni-Cad batteries – Special rechargeable batteries that use Nickel Cadmium.

Open flash technique – Flash illumination that is used with a camera that has been set to B. This technique is often used for providing selective illumination in interiors.

Photoflood – A special type of light bulb that provides illumination for photography.

Polariser – A special filter that is used to reduce reflections in shiny objects. It is also helpful for increasing the intensity of blue skies. Can be in the form of a screw-on lens filter or as a large sheet that can be cut to size.

Power pack – A stand-alone unit that provides a steady supply of power for one or more studio flash units.

Reflector – An object, such as a piece of card, a mirror or other reflective material, that is used to direct light on to a subject.

Rim light – A light, usually placed behind or to the side, that illuminates the edge of a subject. It is a technique that is sometimes used to light hair.

Ringflash – A flash unit shaped like a circle. Its unusual design creates shadow-free lighting that is used for close-up and some types of portrait photography.

Scrim – A cloth-like material that is placed over the light source to provide diffused lighting.

Slave unit – A tiny stand-alone receptor that is used to trigger flash units that are not physically connected to the camera. Several flash units can be triggered in this way. Slave units are handy for selectively illuminating large interiors.

Slow speed flash sync – This is a feature found on some high-level cameras, the flash duration corresponds to selected slow shutter speeds.

Snoot – A tube used for directing illumination in the shape of a narrow beam.

Softbox – A large box diffuser that is placed over a light source, producing a large area of soft, even lighting.

Spot – A device fitted over a light source or built into a light source, that provides a very narrow, directional light beam.

Spot-metering – A feature that measures a very narrow area of light on a subject. This is to ensure accurate exposure for one part of a subject, or to take several light readings to obtain an average exposure.

Stroboscopic flash unit – A special flash unit that emits several small, high-intensity flashes in quick succession. It can be used to freeze fast action, resulting in images that show sequences of a fast-moving event. N.B. Not to be confused with a strobe, which is sometimes used as an alternative term for a conventional flashgun.

Vignetting – An effect that shows as a dark soft-edged border around the edges of an image. Accidental vignetting can be a result of too many filters placed over a lens, or a wrongly sized lens hood placed over the front of a lens. Deliberate vignetting is used to mimic an old-fashioned photographic portrait.

Acknowledgements

We'd like to thank Digital Vision, Ronnie Bennett and Gerry Coe (whose inspiring black-and-white images are seen on the front cover and throughout the book) for kind use of their images.

We'd particularly like to thank Brenda Dermody for her innovative design and creative input, and the illustrator Austin Carey for his stylish illustrations.

Royalty free digital stock photography

Digital Vision Ltd., Chelsea Reach, 79–89 Lots Rd, London SW10 ORN
Tel: +44 (0)207 351 5542 Fax: +44 (0)207 351 6487
Website http://www.digitalvision.ltd.uk